D0131862

JUNGLES

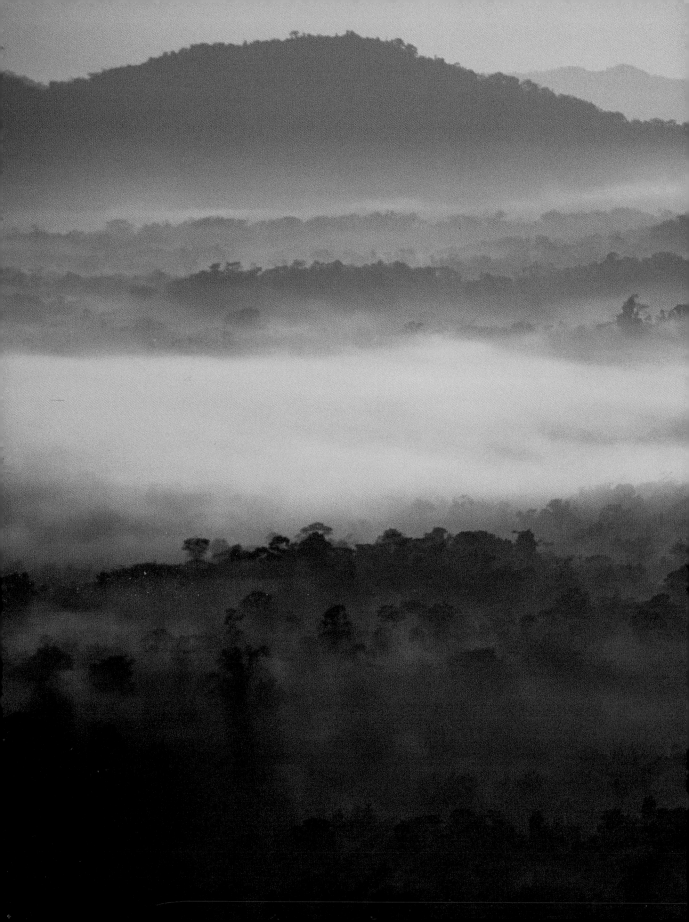

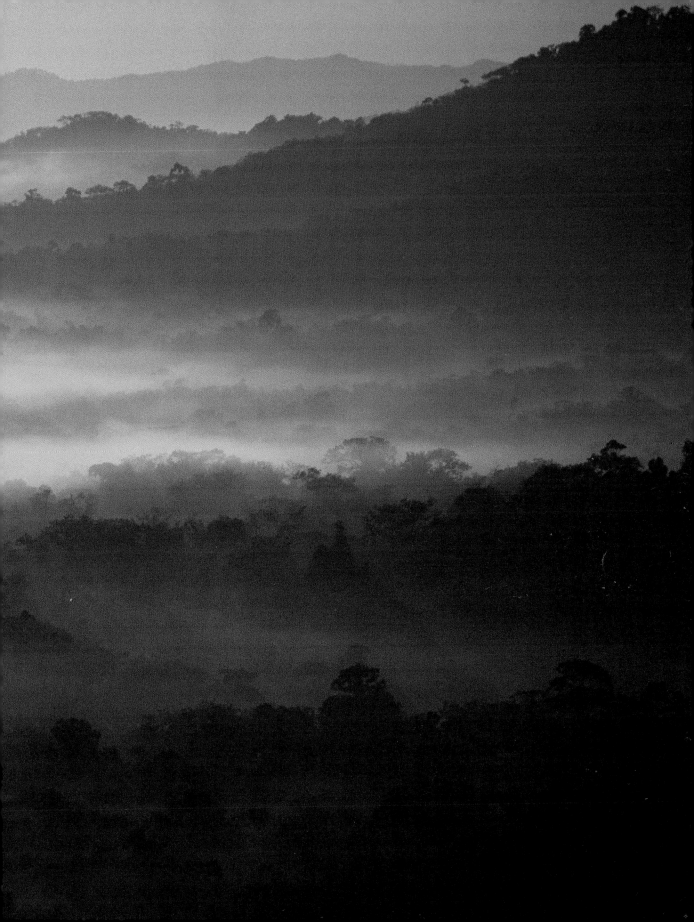

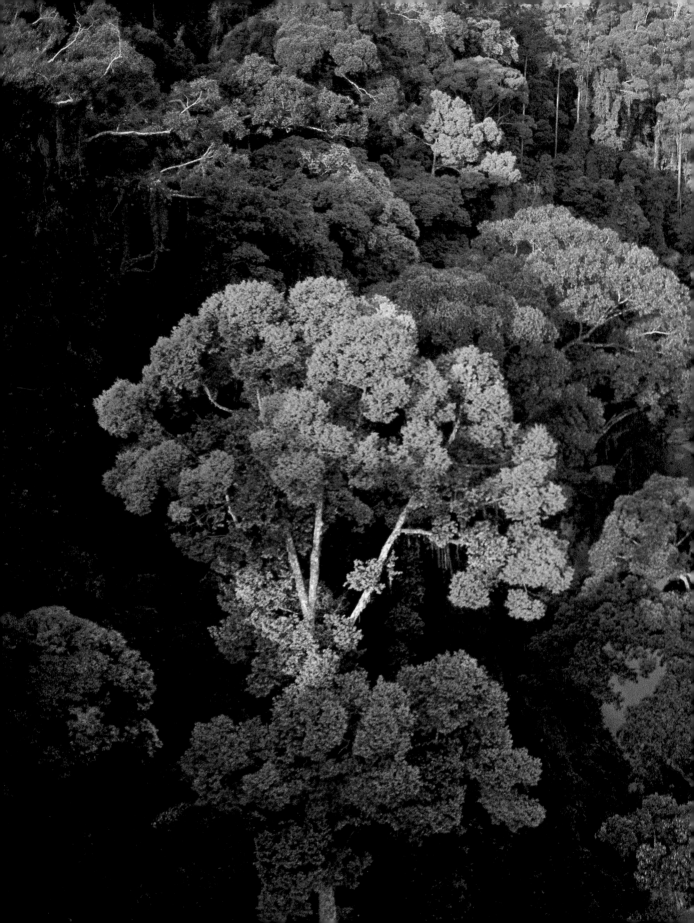

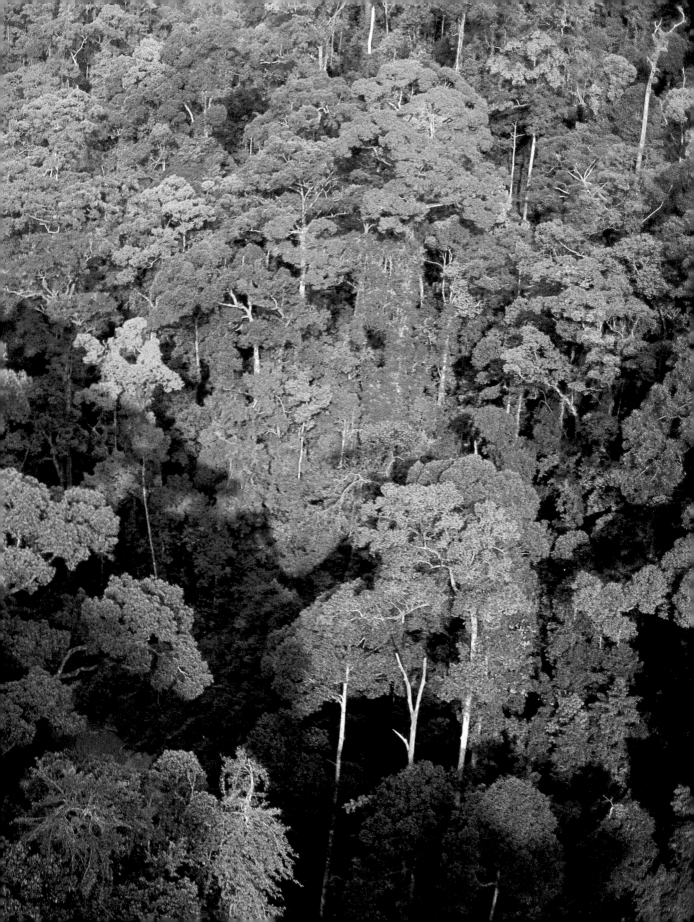

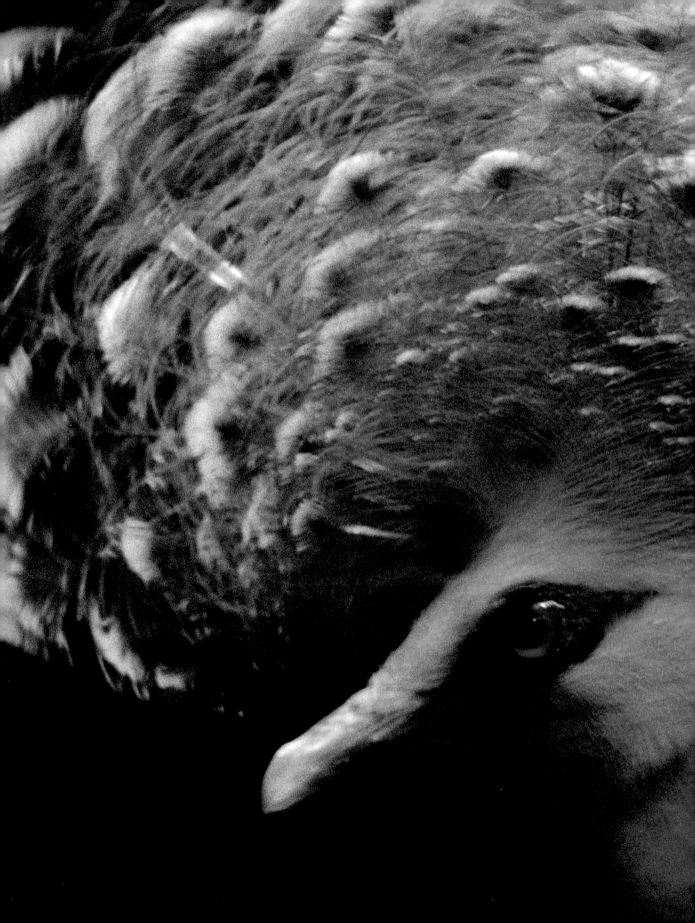

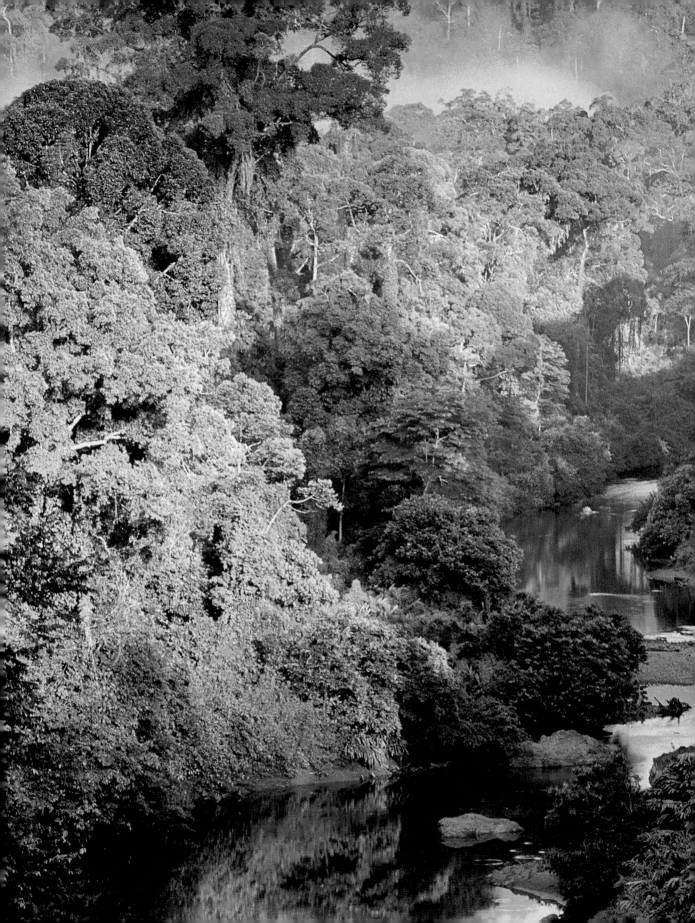

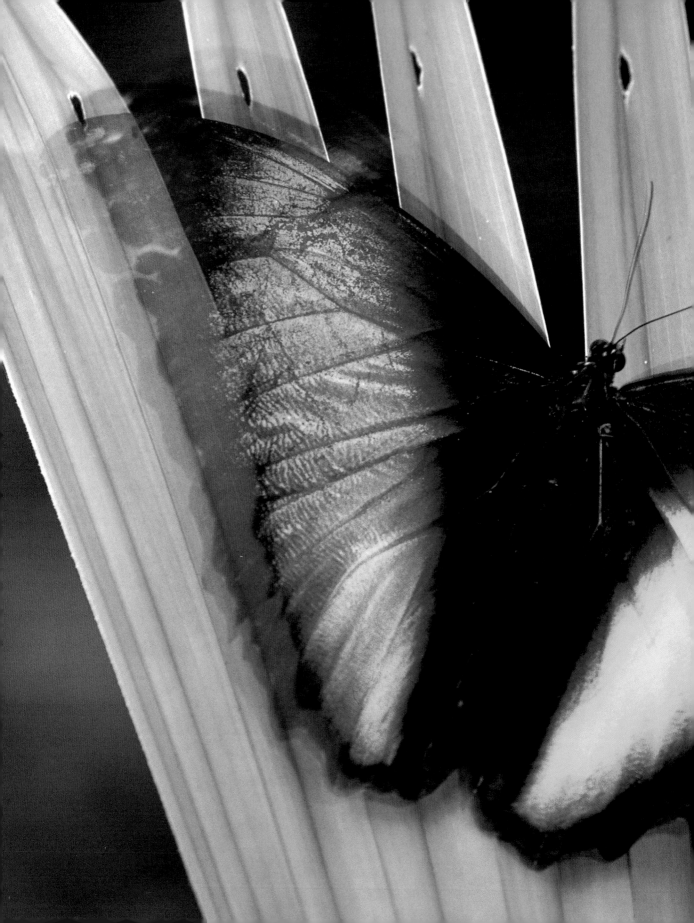

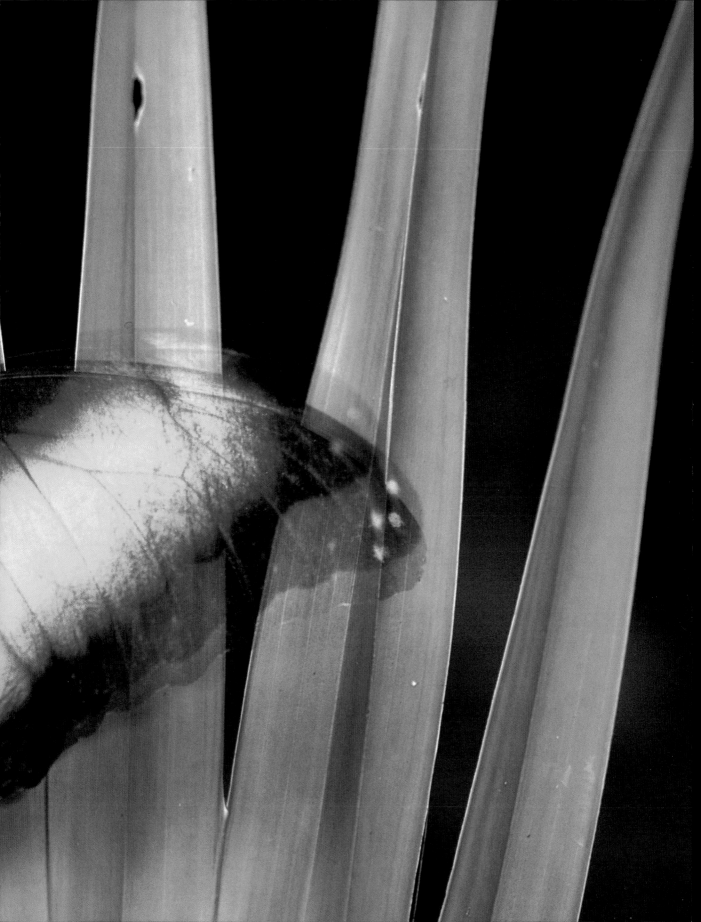

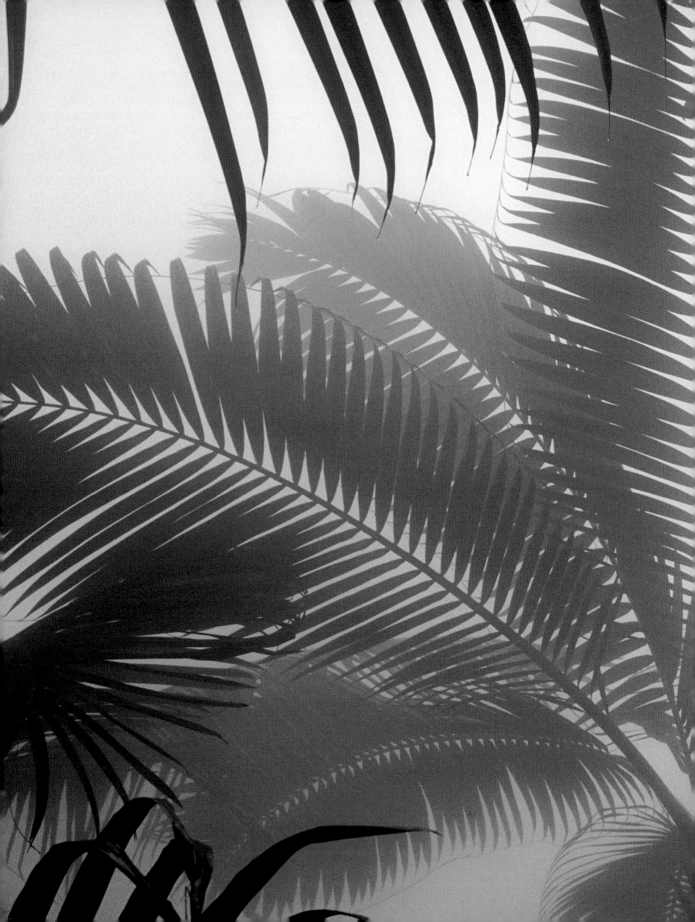

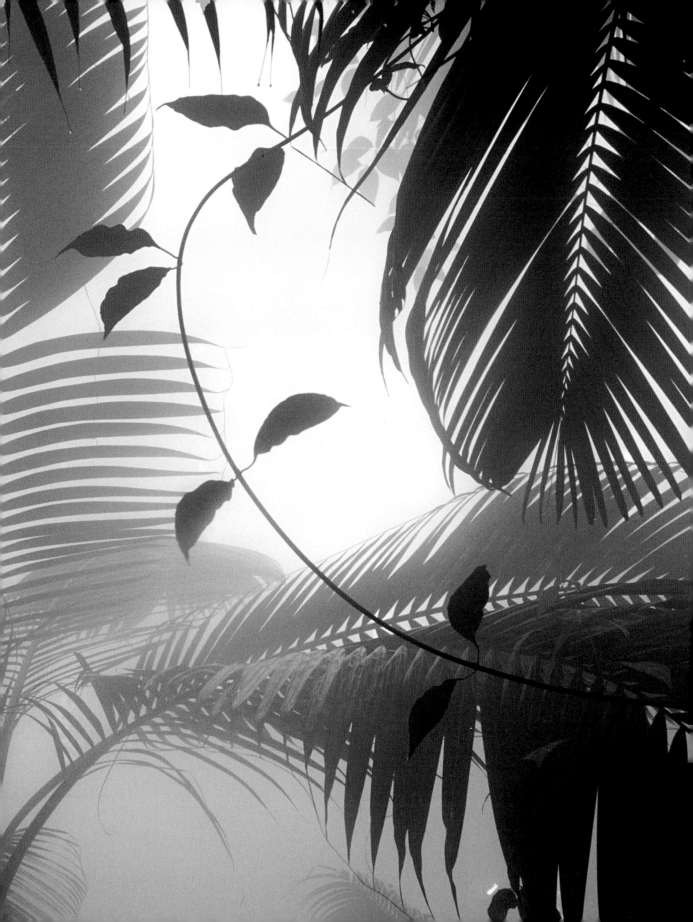

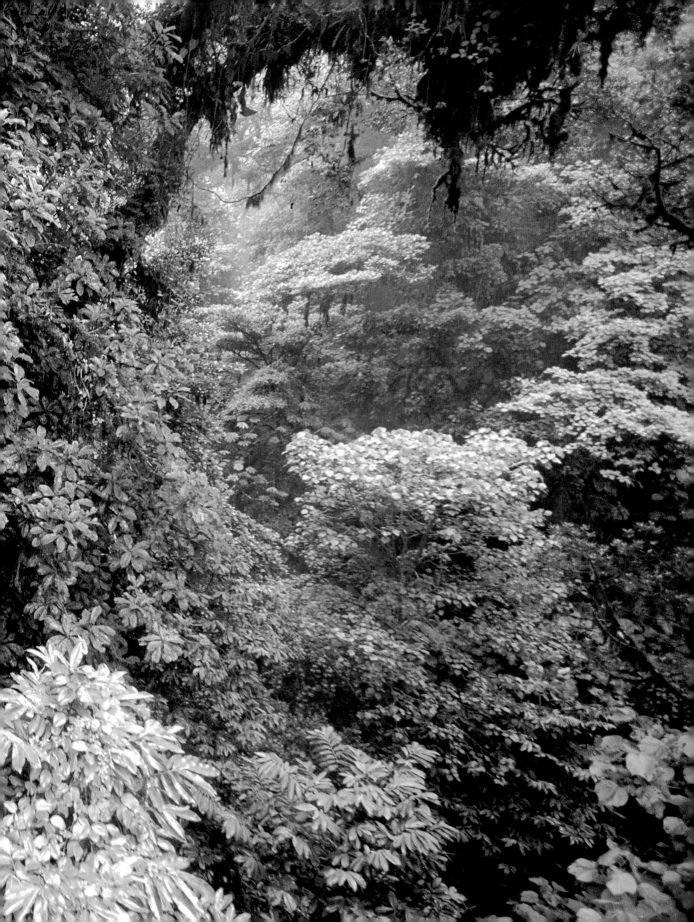

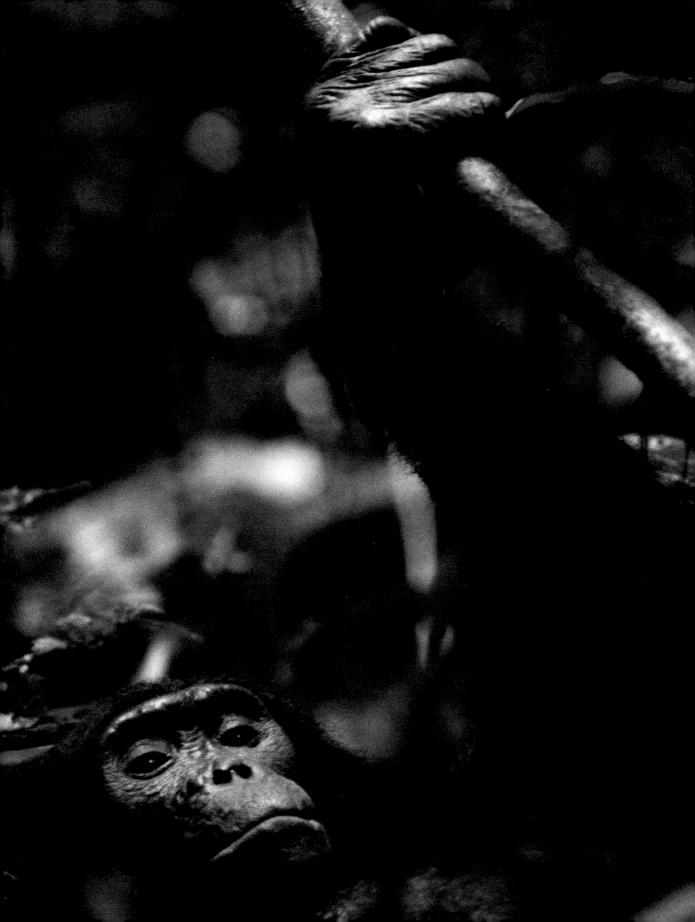

JUNGLES

FRANS LANTING

EDITED BY
CHRISTINE ECKSTROM

TASCHEN

KÖLN LONDON LOS ANGELES MADRID PARIS TOKYO

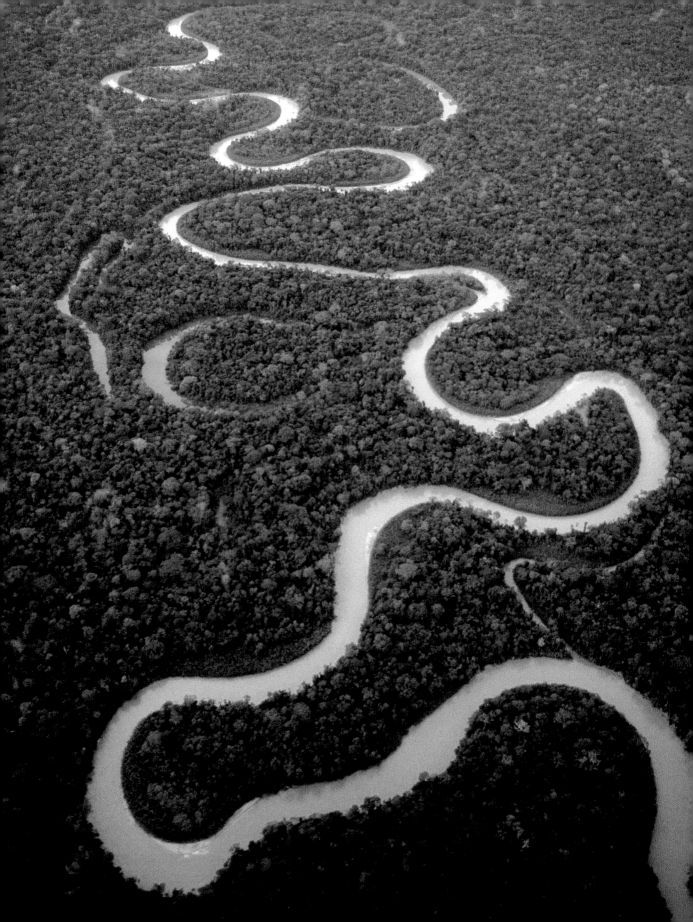

INTRODUCTION

My first trip to the tropics changed my outlook on nature. From my native Holland, where nature is dormant part of the year and restrained by a temperate climate the rest, I flew to equatorial Surinam, where I stepped into a world of hot color and green abundance. A small plane dropped me at an airstrip cleared from the forest; a canoe ride away was an isolated camp in the middle of the jungle. Real jungle. This was part of the biggest expanse of equatorial rainforest in the world—the Amazon Basin, which stretches, even today, across an area the size of Western Europe.

I lay awake in a hammock that first night, unable to sleep because of the frogs. In Holland I was accustomed to hearing a few frogs at a time. In Surinam that evening I heard hundreds simultaneously—tinkling, honking, and whistling in a tapestry of sound unlike anything I had ever heard. The chaotic calls of countless individuals merged into mesmerizing patterns of pulses and crescendos that vibrated through the night. It was my first experience with the rhythms of the jungle and the complexities of life which those sounds represented. That night the seeds for this book were sown.

In the 20 years since, I have traveled to jungles around the world. My missions were often urgent—to search for an animal never photographed before; to join a scientist at a scene of discovery; to document conservation issues from the front line. In Brazil I followed the largest primate of the Americas, the muriqui, in an isolated forest reserve surrounded by farms. In Hawaii I struggled through a bog near the wettest spot on earth, and strained to hear the song of a bird believed to be the last of its kind. In Madagascar, by contrast, researchers showed me the first of a kind, a lemur new to science, an animal not yet even named.

For this book I have taken a step back from the objectives of those journeys and selected images to show what ties them together. I made a deliberate choice to present jungles without reference to the human forces that are transforming tropical forests around the world at an alarming rate. In this work I chose to show jungles in their natural splendor, and their animal inhabitants with the dignity they deserve. I want to show what is at stake, and what conservationists, including myself, have to fight for. I hope these photographs resonate with the sense of wonder that has compelled me to go back time and again to the world of the tropics.

The term jungle comes from an old Sanskrit word. *Jangala* originally meant impenetrable vegetation, but since the term took hold in the English language it has come to mean much more. I like the word jungles precisely because of its imprecise meaning. It leaves room for the imagination. Among scientists it has been replaced by specific terms for various kinds of tropical

ecosystems, such as cloud forest and lowland rainforest, but to me jungle still fits the need for a term that describes an uncontrollable natural abundance beyond human grasp.

The very nature of jungles stretches the limits of photography. While the essence of photography is to show, jungles hide, or at best, suggest. It is hard to capture their complexity in a single image. So I opted to show impressions of jungles to evoke a sense of their kaleidoscopic nature—the glimpses of faces that melt into shadows, the bursts of color and shimmering light, the way darkness rises in the forest and vision gives way to sound and scent. This book is a personal vision of jungles. It is about the feeling of the forest rather than the science of it.

In *Jungles* the results of travels, years and continents apart, are shown intertwined, to stress the parallels and connections I observed in different places. The book features four portfolios of images organized around a series of concepts. Embedded within each of the four chapters are stories from jungle expeditions, balancing the abstractions of the visual narrative with experiences from the field. "Water and Light" shows the interplay of these elements with plant and animal life, and ends with a story about the forest after dark in the jungles of Central America. "Color and Camouflage" explores the need to hide and the desire to be seen, and concludes with a journey to a remote part of the Amazon Basin to document macaws. "Anarchy and Order" features impressions of growth and movement, and leads to a trek up a mountain in Borneo whose forested flanks show a unique layering of life zones. "Form and Evolution" is an ode to the wonders of natural selection, and culminates in encounters with primates in the forests of Madagascar and Africa.

As an homage to great scientists who have influenced my own perspective on jungles, I have included passages by the evolutionary biologist Edward O. Wilson; the 19th-century explorer of tropical South America, Alexander von Humboldt; the writer-philosopher Loren Eiseley; and Charles Darwin, whose words from the conclusion of *On the Origin of Species*, "endless forms most beautiful," have run through my mind like a mantra while exploring jungles on my own.

What I know about jungles has come from two decades of fieldwork that have given me both an appreciation of the limits of my knowledge and a hunger to return to know more. I owe what I know to many, from a geography teacher who cast a spell on me with his descriptions of the tropical forest, to field biologists who have unraveled its inner workings. Many others, from world-renowned scientists to local guides with tribal knowledge, have shaped my understanding of what I witnessed and photographed.

This book is a tribute to all of them—a tribute to those who have led me in and out of jungles, those who sheltered me while I was there, those whose lives depend upon these vital ecosystems, and especially to those who are the guardians of jungles, both now and for tomorrow.

Frans Lanting
Santa Cruz, California

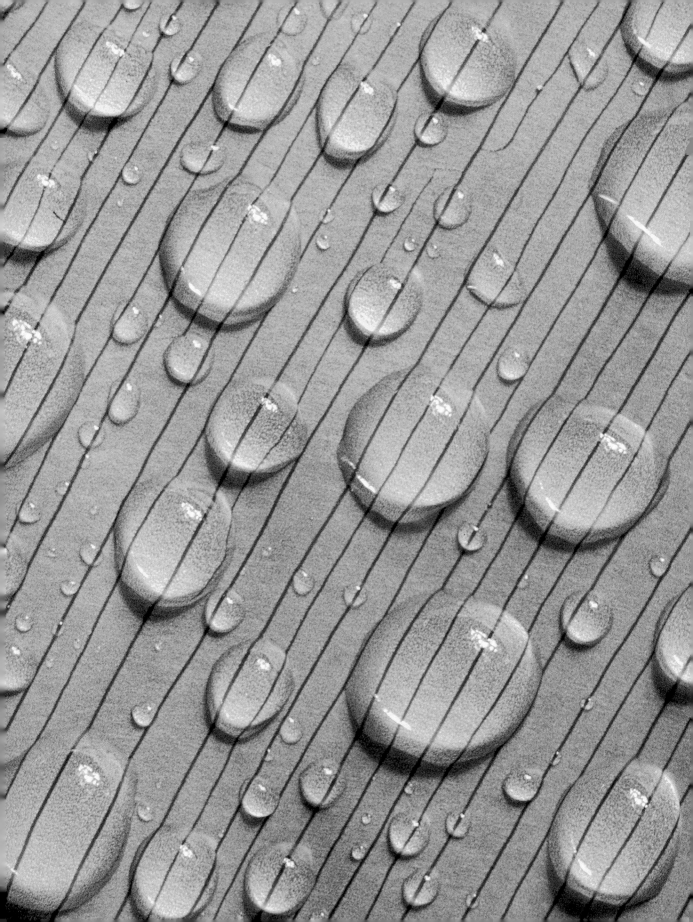

WATER + LIGHT

The unsolved mysteries of the rain forest are formless and seductive.
They are like unnamed islands hidden in the blank spaces of old maps, like dark shapes
glimpsed descending the far wall of a reef into the abyss.
They draw us forward and stir strange apprehensions. The unknown and prodigious are
drugs to the scientific imagination, stirring insatiable hunger with a single taste.
In our hearts we hope we will never discover everything.
We pray there will always be a world like this one at whose edge I sat in darkness.
The rain forest in its richness is one of the last repositories on earth of that timeless dream.

Edward O. Wilson, "Storm over the Amazon," *The Diversity of Life*, 1992

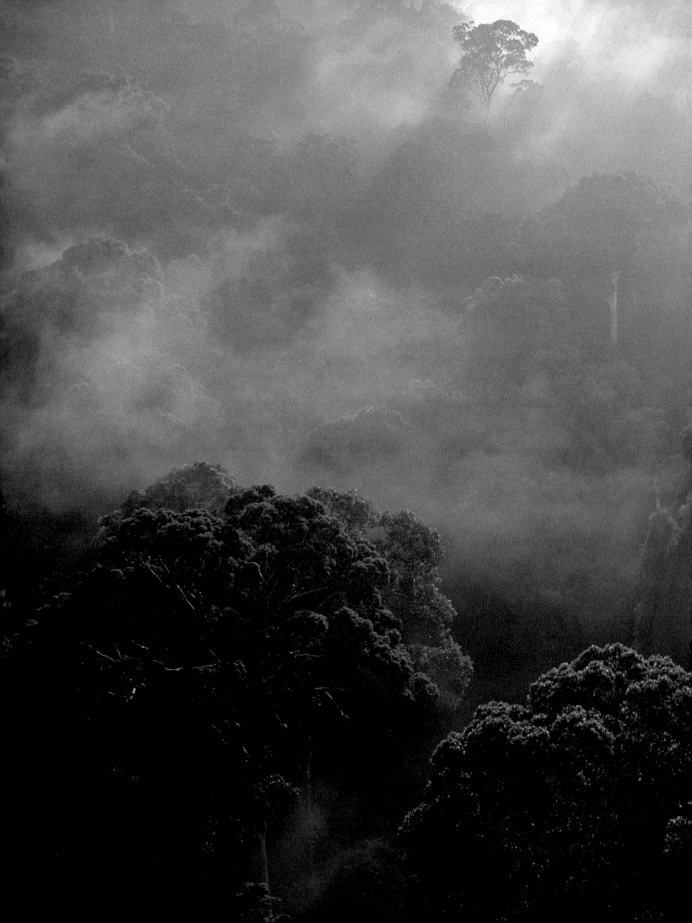

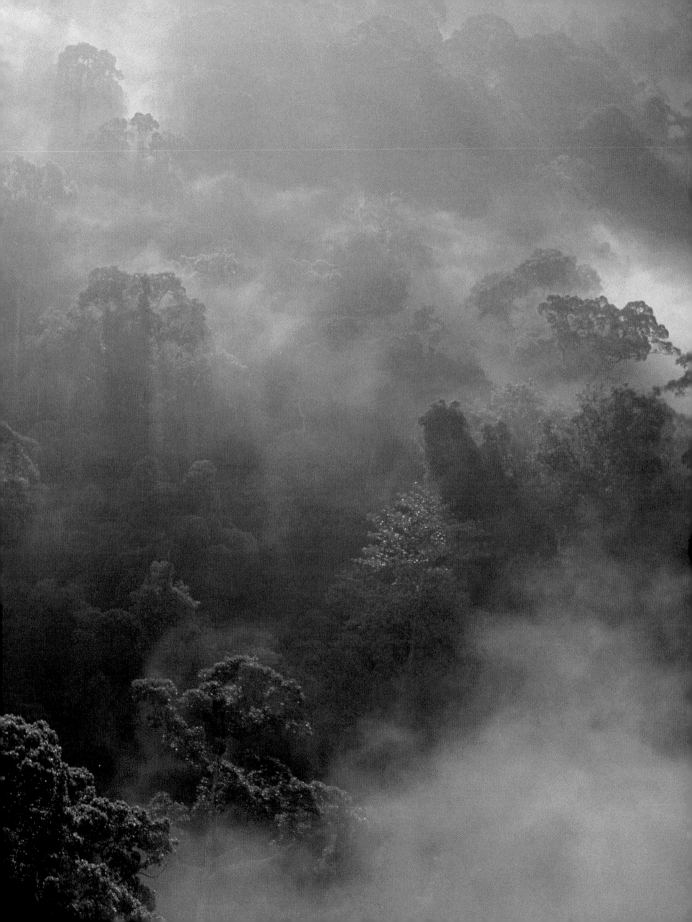

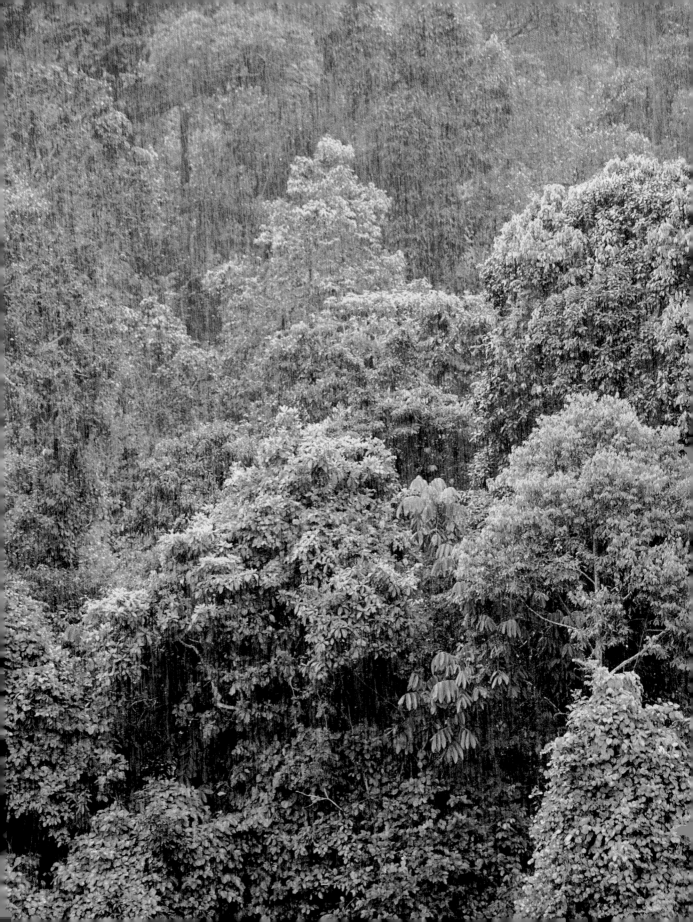

RIGHT: *Fern, Borneo*
FOLLOWING PAGES:
PAGES 34–35: *Morning Mist, Peru*
PAGE 37: *Frog in Mushroom, Borneo*
PAGES 38–39: *Waterfalls, Brazil*

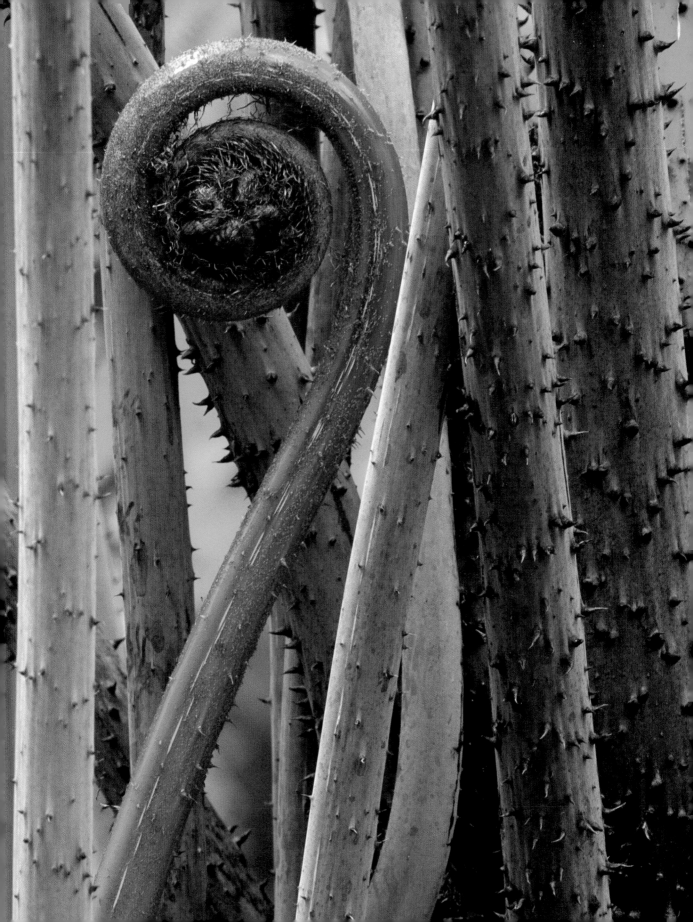

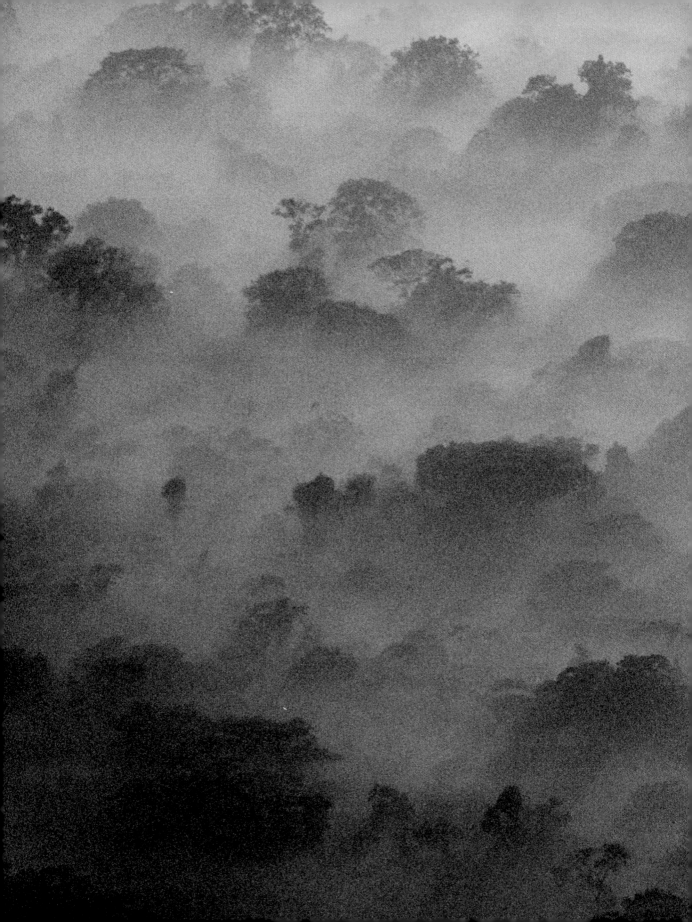

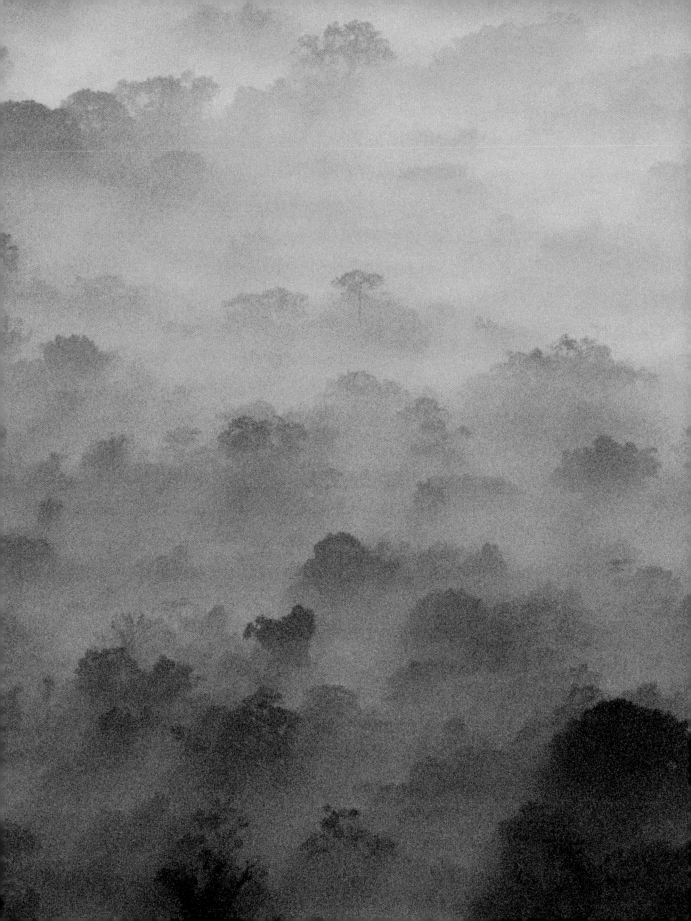

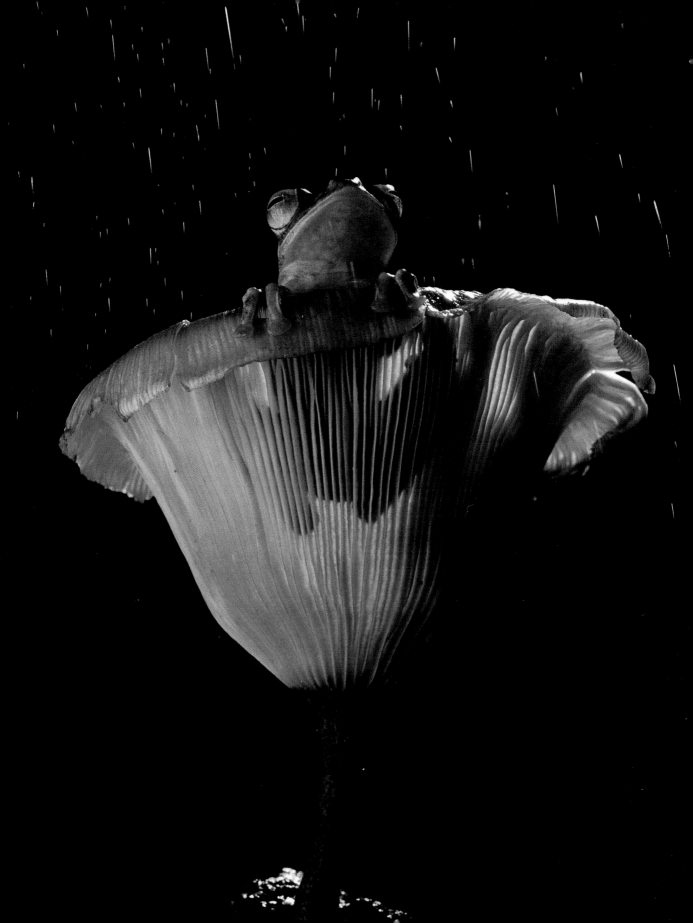

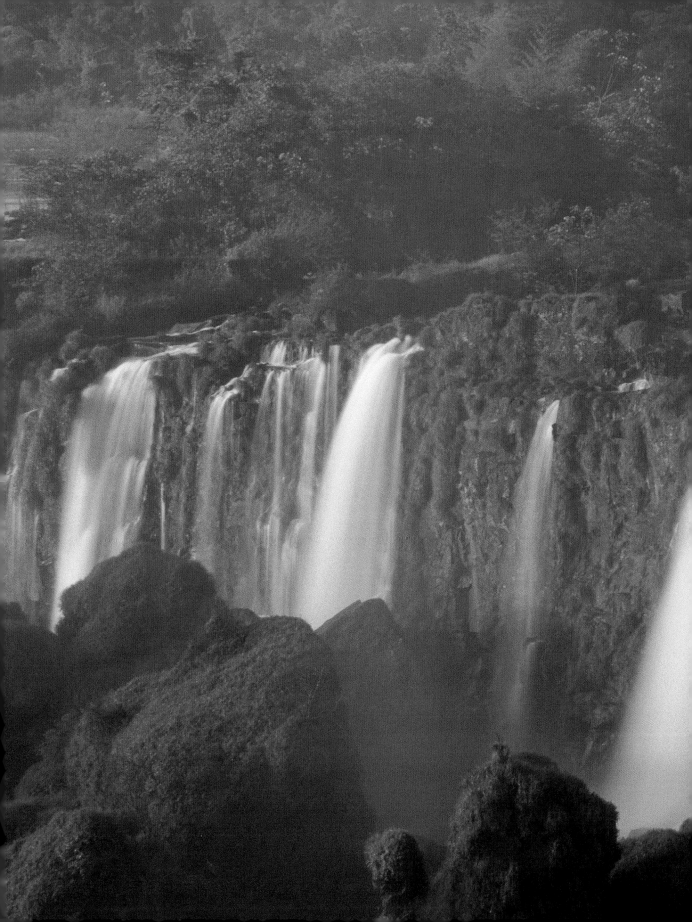

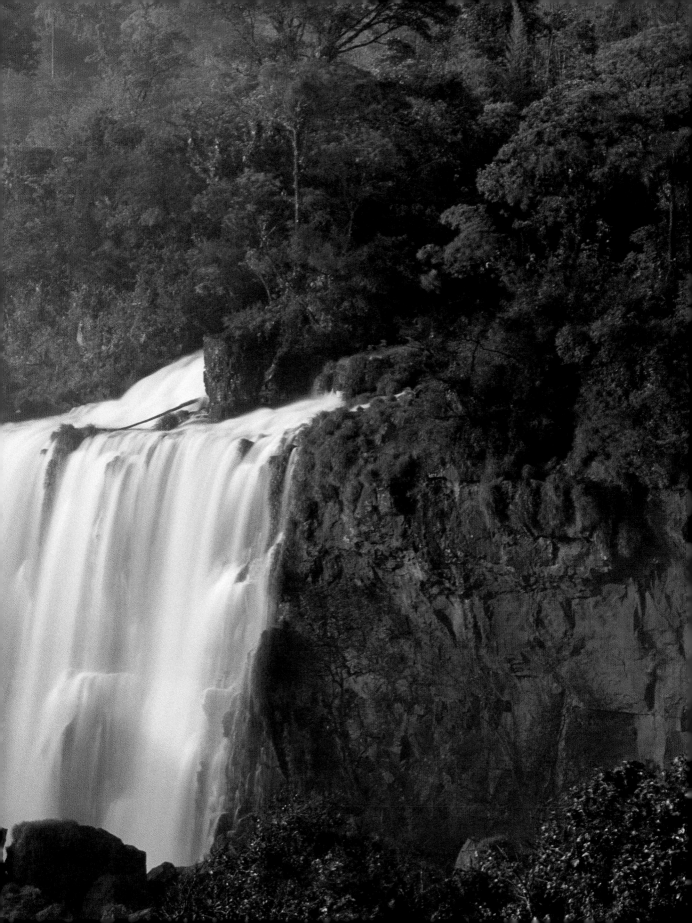

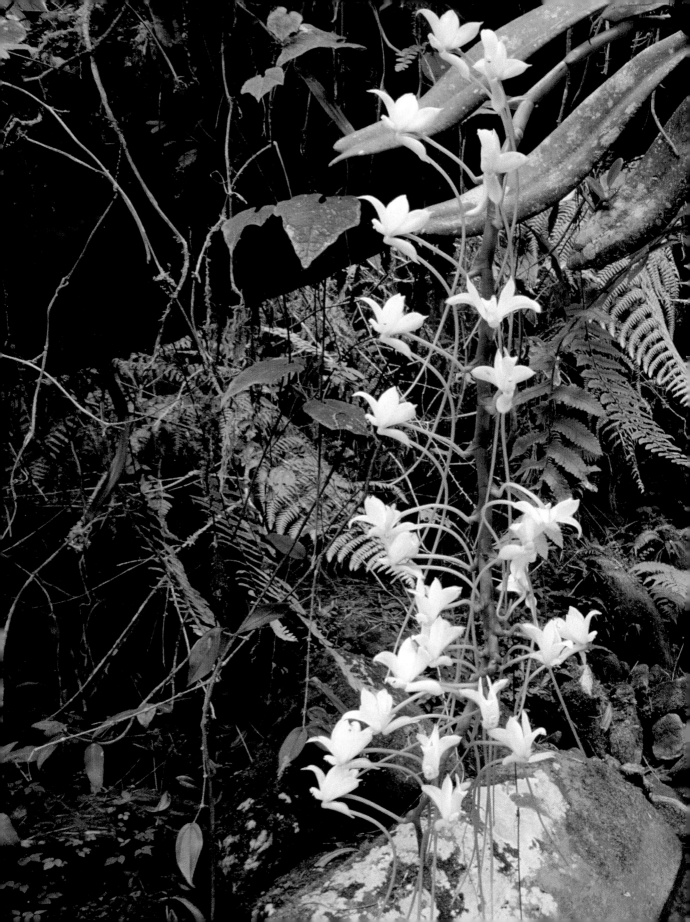

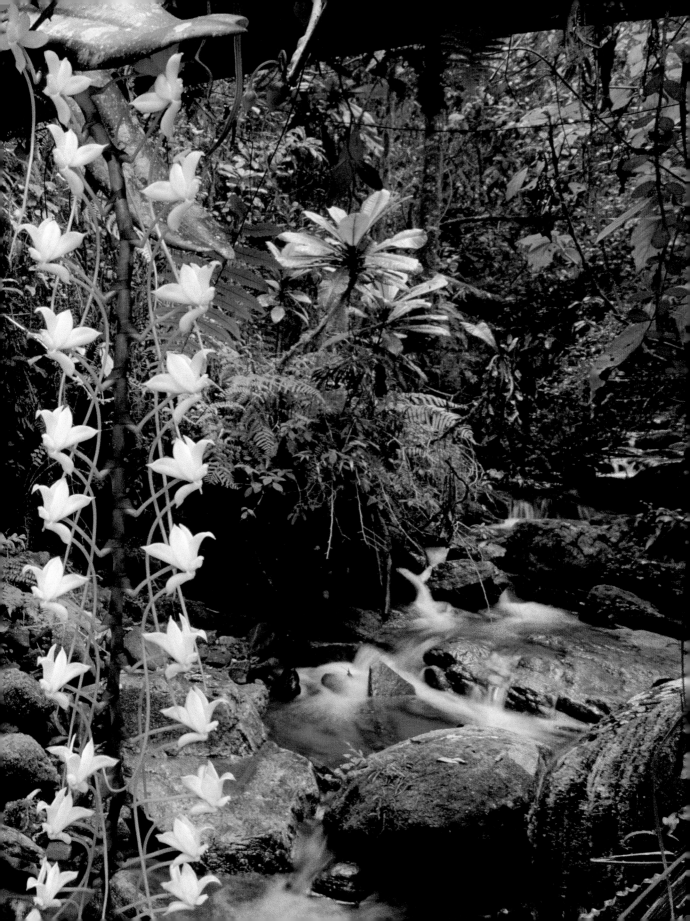

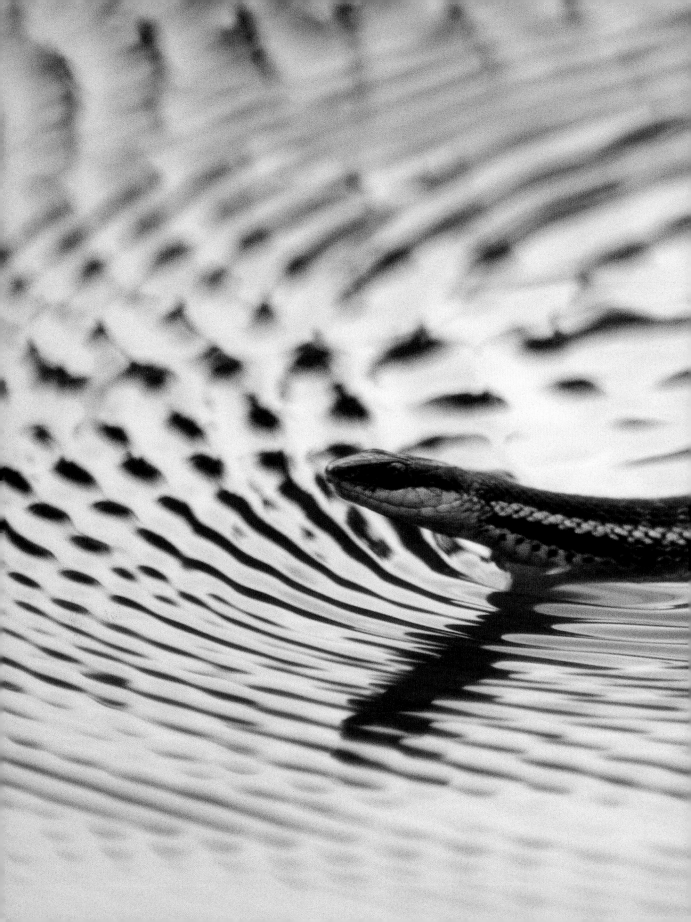

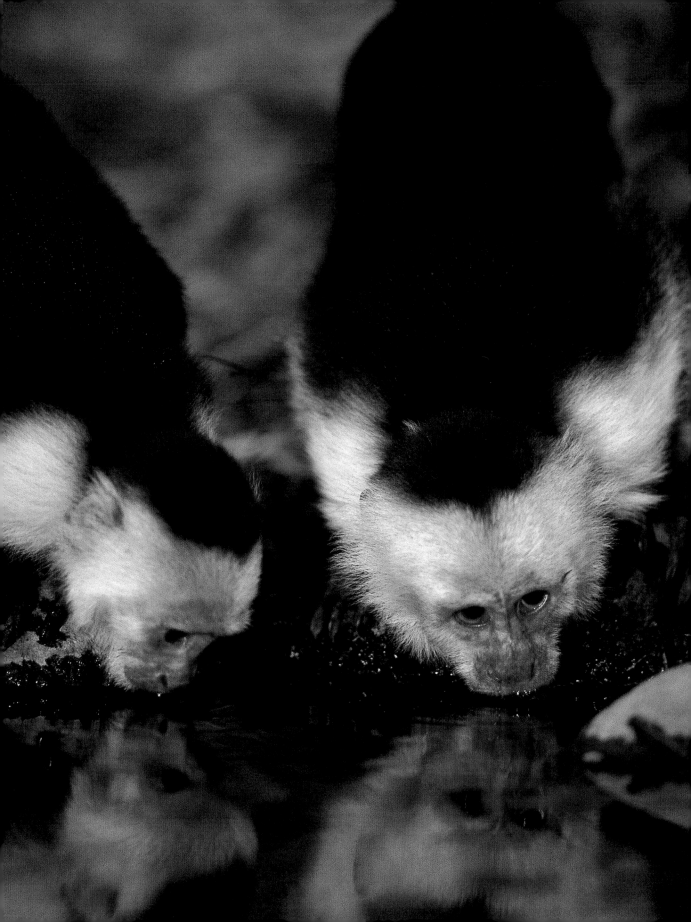

LEFT: *Capuchin Monkeys, Costa Rica*
PREVIOUS PAGES:
PAGES 40–41: *Orchids, Madagascar*
PAGES 42–43: *Swimming Snake, Madagascar*

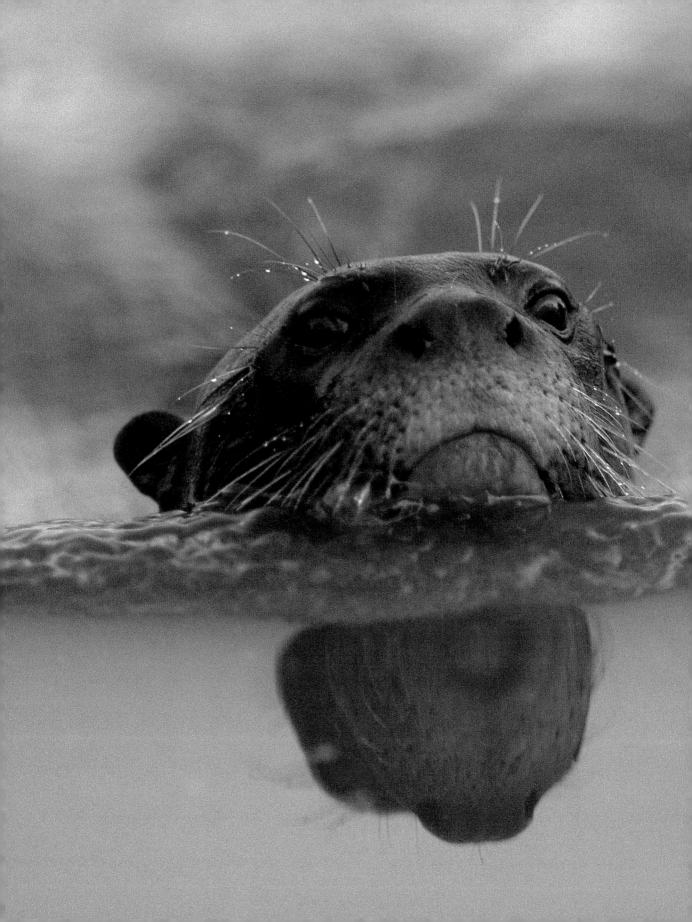

47

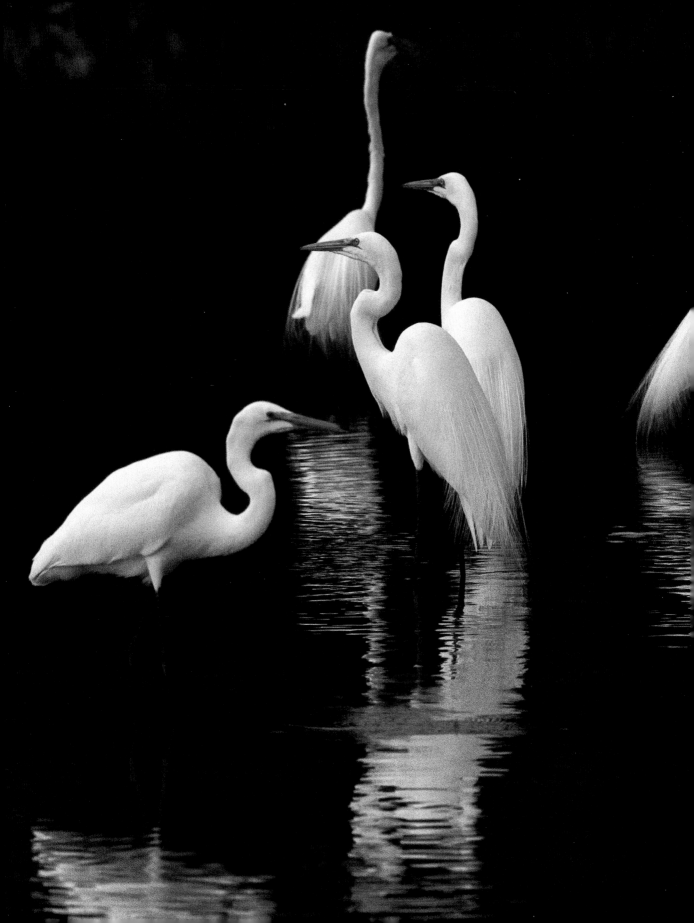

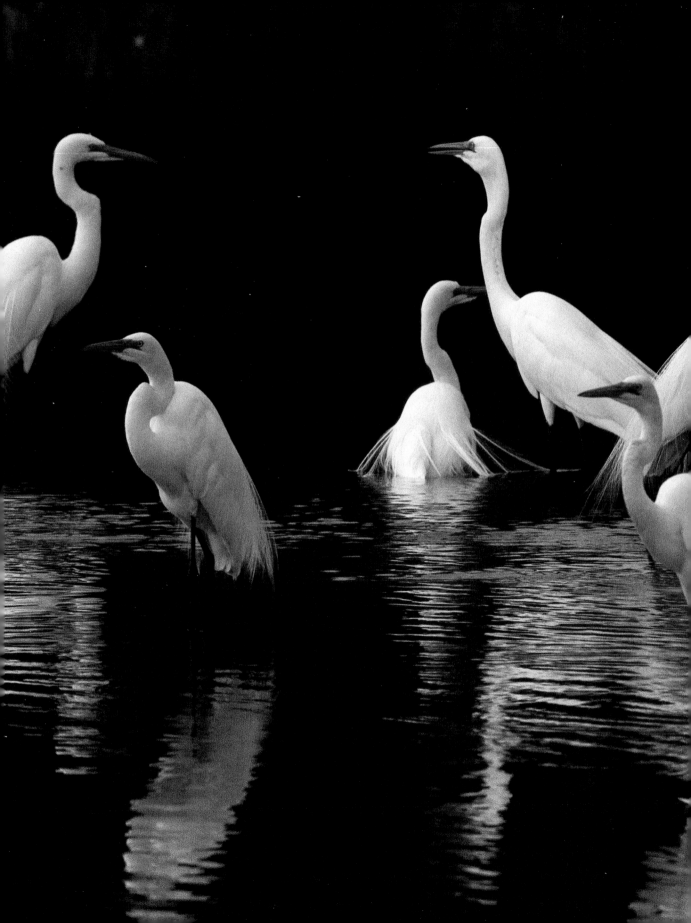

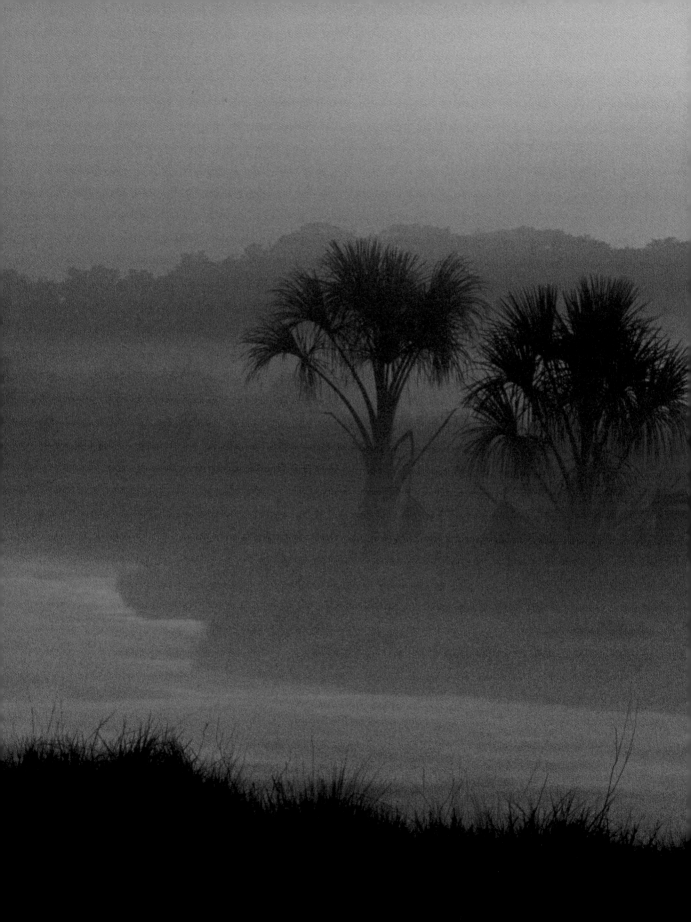

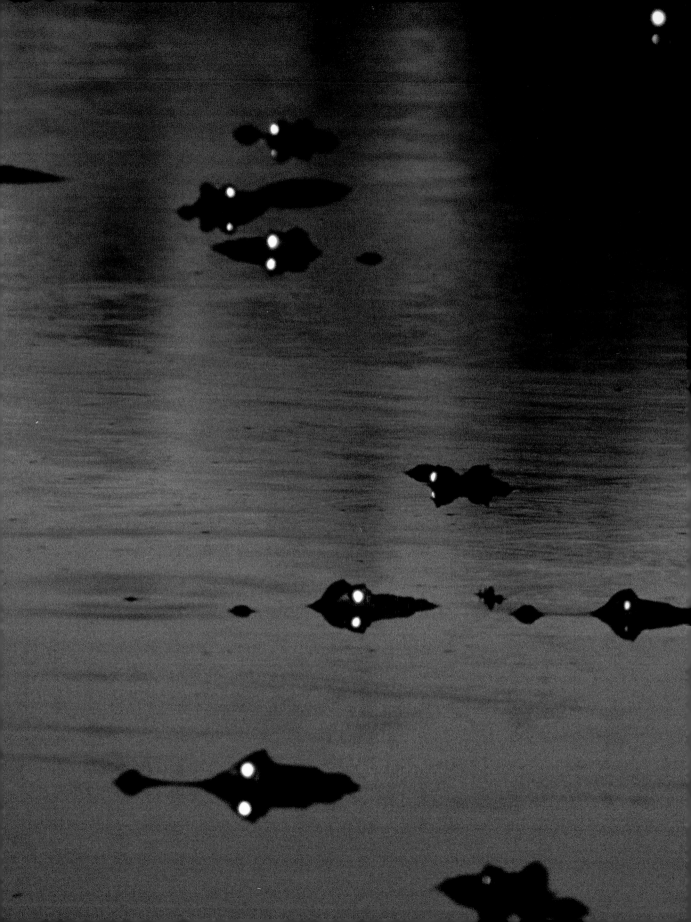

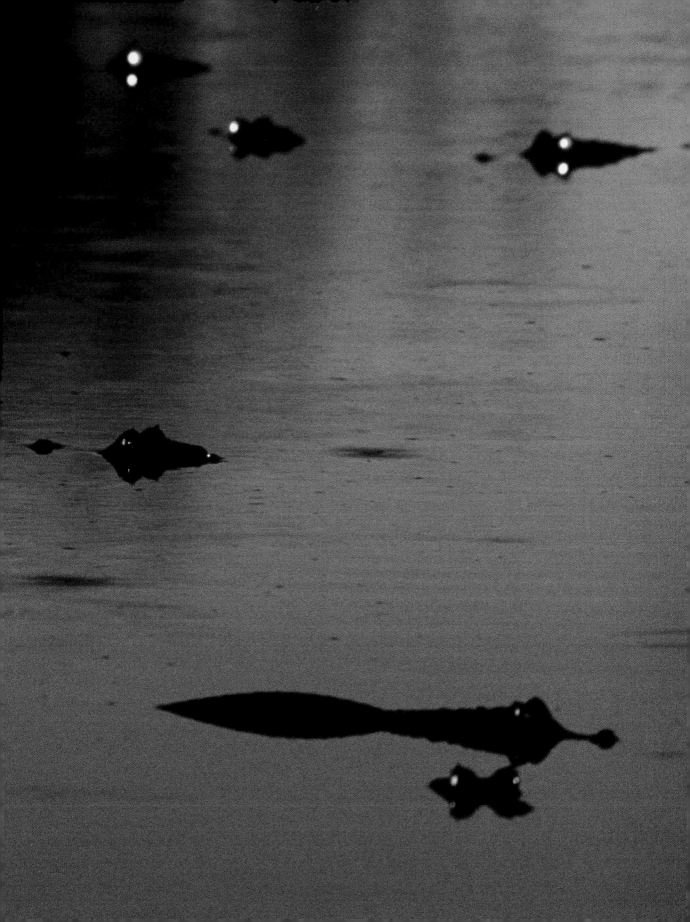

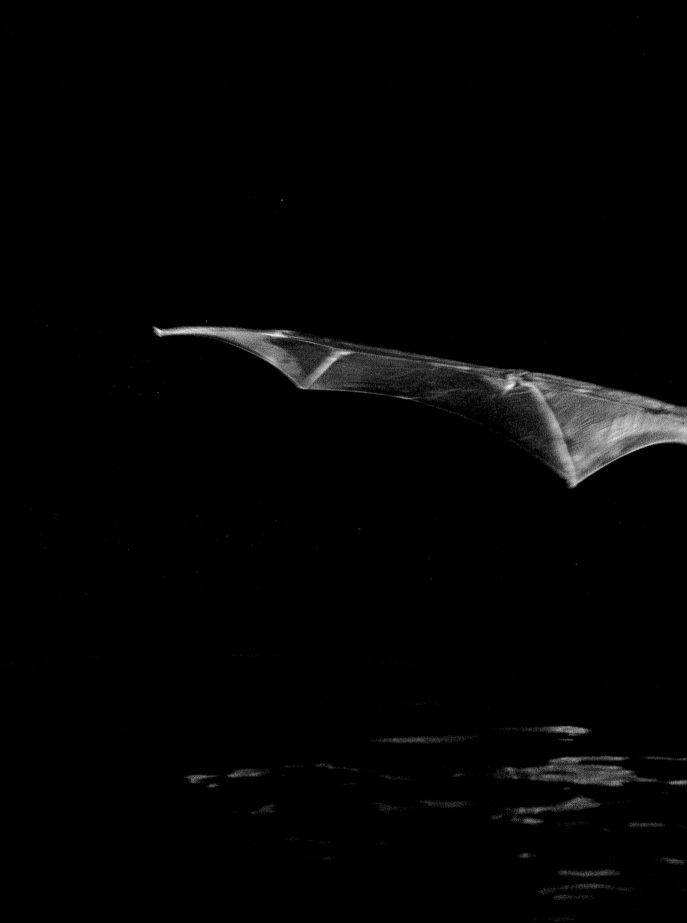

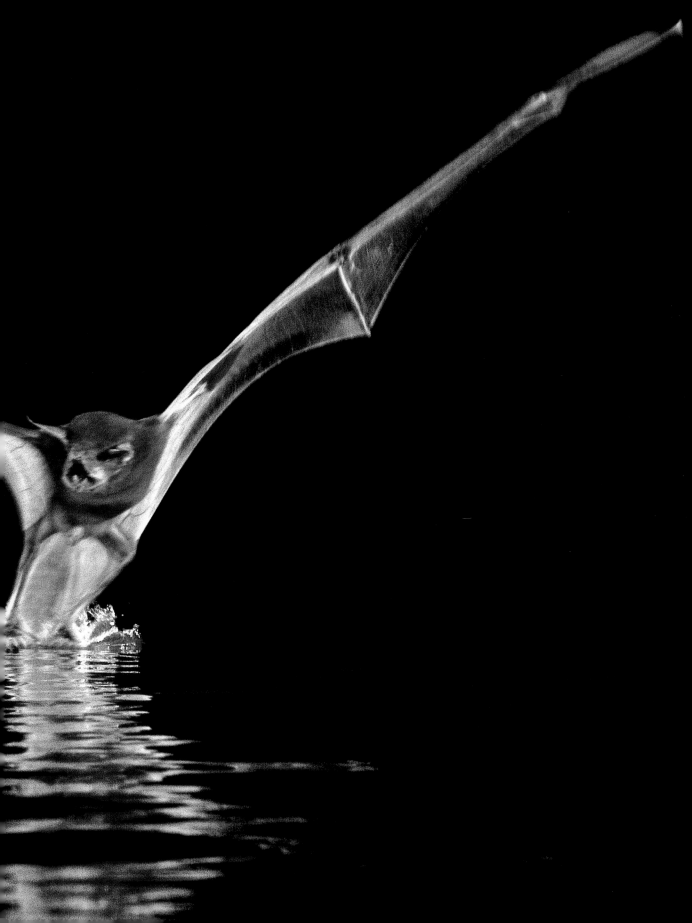

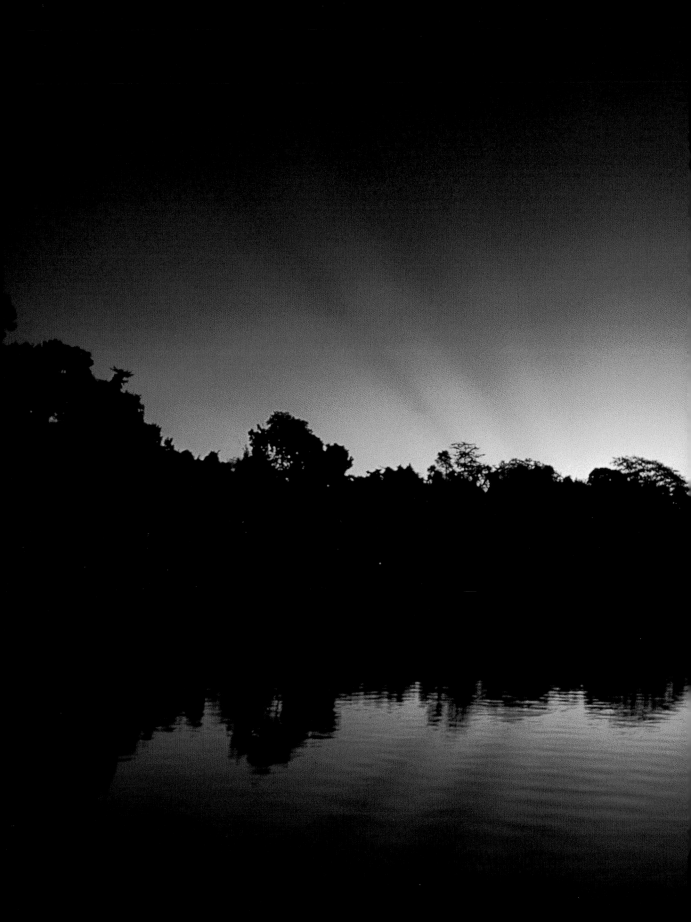

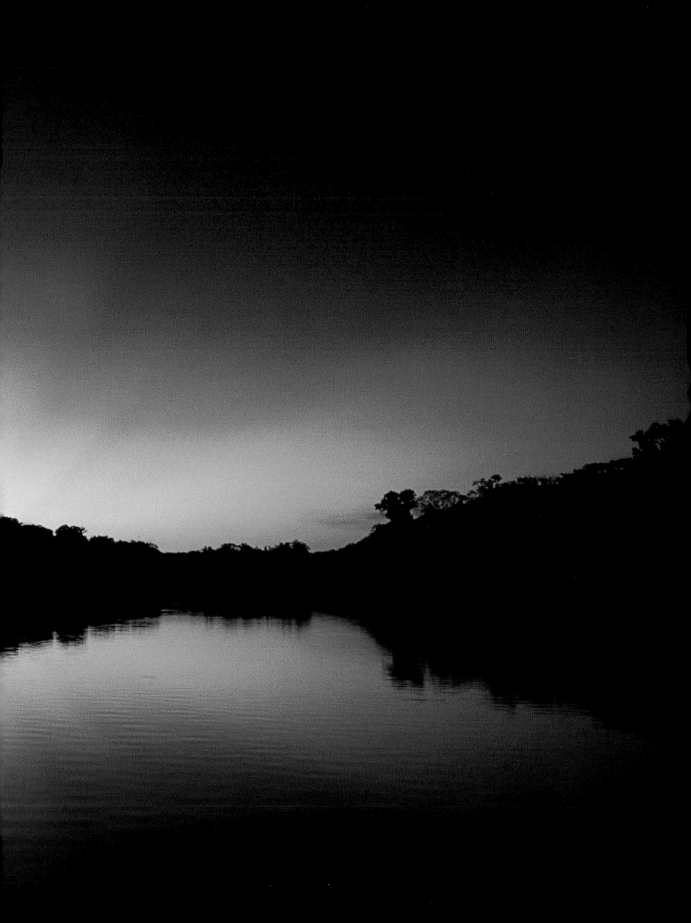

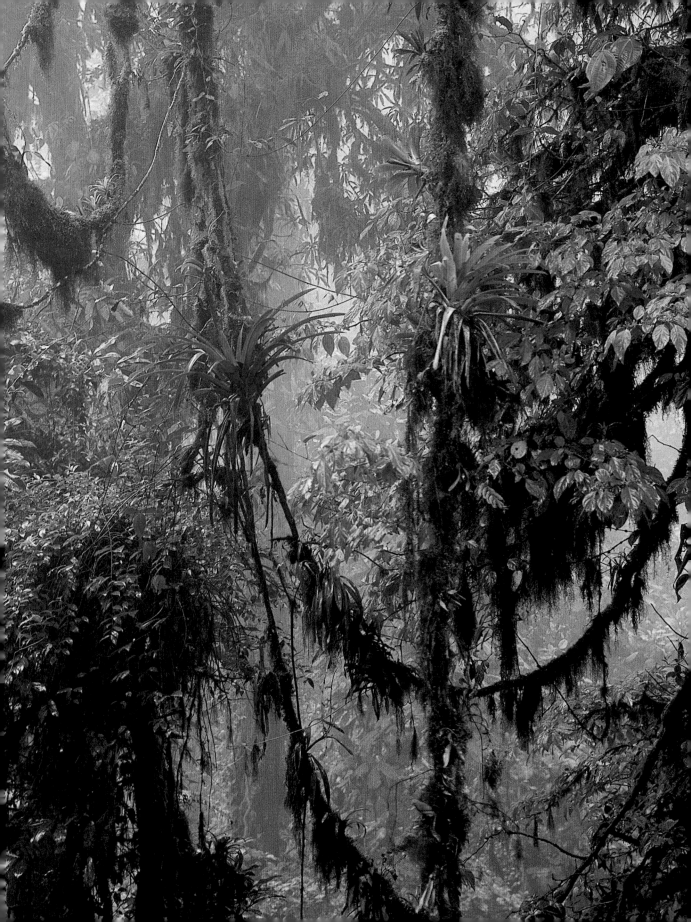

SENSING THE NIGHT

Thunder crackles over the darkening jungle of La Selva, a rainforest along the Caribbean slope of Costa Rica. It has stopped raining, but inside the forest everything is still drenched and dripping. As daylight fades, the last birds hurry away to seek shelter for the night and an insect chorus begins to swell. I can hear them from inside my cabin at the edge of the forest. From my door it is only ten steps to the alien world of the jungle after dark. Even though I have entered this forest many times before, now, in twilight, the landmarks are different. The trail seems narrower, the trees closer. The air is still and heavy with scents—the smell of a flower luring nocturnal pollinators, the musky odor that betrays the passage of a herd of peccaries.

Down the trail I spot the waving flashlights of the two scientists I am joining tonight to search for insects. Piotr Naskrecki has an infectious enthusiasm for the family of bizarre insects he studies. He shows me a huge katydid with waving antennae who is making a rasping sound by scraping his wings together. Each katydid has a different acoustic fingerprint, Piotr explains, and those features are a better way to tell species apart than by looking at them. The universe of katydids is governed by sound. By day they hide, using an assortment of fantastic disguises ranging from dead leaves to moss to avoid detection by birds. By night they feed and search for each other. In many species only the males call; females listen for them through ears positioned on their knees.

At night what you look like is not as important as what you sound like. Piotr points out a surreal katydid he affectionately calls a "flat-faced pit bull." This fierce-looking insect produces sounds using a variety of mechanisms: Males can stridulate using their wings, vibrate using their bodies, or drum using their hind legs. But no matter at what frequency they broadcast, they face sudden death from predators tuning in to their calls. Several dozen species of bats are active here, and many of them hunt katydids. In the neotropics, nocturnal bats fill many of the niches occupied by birds by day. They eat fruits, forage from flowers, and hunt insects. But where birds use their superb sense of sight, bats exploit their specialized sense of hearing. They produce high-frequency sounds and listen with finely tuned ears for the echo. With this feedback they locate prey and navigate through the dense forest after dark as easily as a bird in broad daylight.

Most of these acoustic games of hide-and-seek are being played out at frequencies beyond the range of human hearing, but Piotr Naskrecki's colleague Glenn Morris has brought a device with him that translates ultrasonic sound into patterns we can hear. When he switches on his bat detector, suddenly the forest is full of sounds. Bats and insects crowd the airwaves with staccato

LEFT: *Cloud Forest, Costa Rica*

bursts of clicks, chirps, and beeps like radio stations overlapping on an AM band.

Insects are not the only creatures at risk. Researchers on the island of Barro Colorado in the Panama Canal found that the calls of male *túngara* frogs are shaped by the presence of frog-eating bats. *Túngara* females prefer males with extended calls, but those, apparently, give a hungry bat a greater chance to strike, forcing the male frogs into the unenviable position of having to choose between sex and survival.

The acoustic intricacies of the jungle after dark go far beyond ordinary human perception. While bats echolocate in the ultrasonic range, many insects are active at the infrasonic end of the acoustic spectrum. Beetles, lacewings, and katydids produce low-frequency sounds using leaves and branches as substrates through which they communicate their presence with vibrations. Operating at closer range, snakes use infrared sensing organs to zero in on their prey, while hunting spiders sense potential victims through hairs on their legs which detect prey movements as subtle changes in air currents. The stillness of the air inside the forest is particularly suited to the use of scents for communication. Ants follow chemical trails laid by workers between colonies and food sources on the forest floor. Overhead, moths find each other through faint pheromone paths in the air.

Yet even the sense of sight plays a role in the jungle at night. Fireflies bring light into the dark with a remarkable technique. They oxidize a compound called luciferin within their own bodies. The energy produced during this chemical reaction is emitted as light, which the male fireflies use to lure females. I have seen their mesmerizing displays in many forests, but one still evening in the humid jungle of Guatemala stands out in my memory. At dusk a flood of fireflies poured out of the forest surrounding the ancient Maya temples at Tikal. Seated on a pyramid I saw the pulsing swarms moving among the sacred stone structures where Maya priests once plotted the course of planets. They flashed silently, so brightly, and in such numbers, that it became hard to tell apart the creatures of the forest and the bodies of heaven.

TOP RIGHT: *Undergrowth, Costa Rica*
RIGHT: *Dead-Leaf Katydid, Costa Rica*
FOLLOWING PAGES:
PAGES 62-63: *Green-Leaf Katydid, Costa Rica*
PAGE 65: *Conehead Katydid, Costa Rica*
PAGES 66-67: *Fishing Bat, Panama*
PAGE 68: *Fruit Bat, Peru*
PAGES 70-71: *Moon and Venus over Maya Temple, Guatemala*

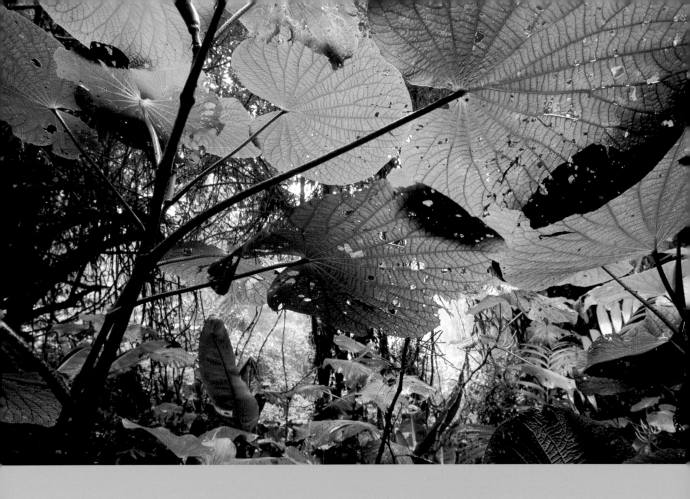

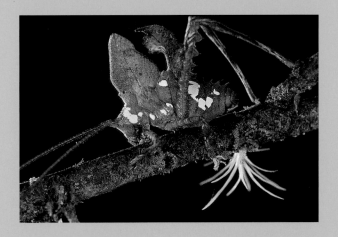

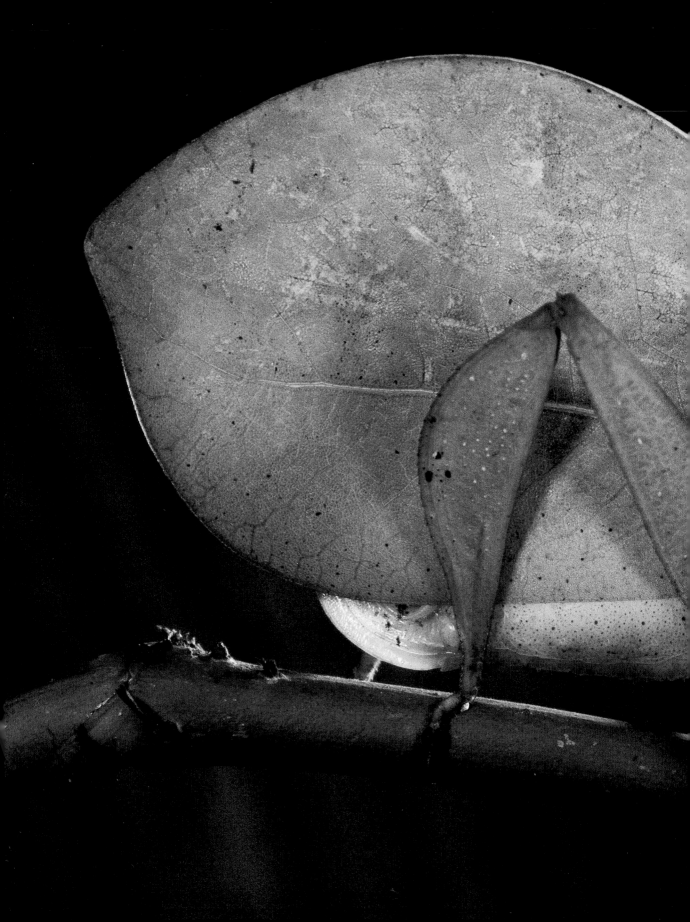

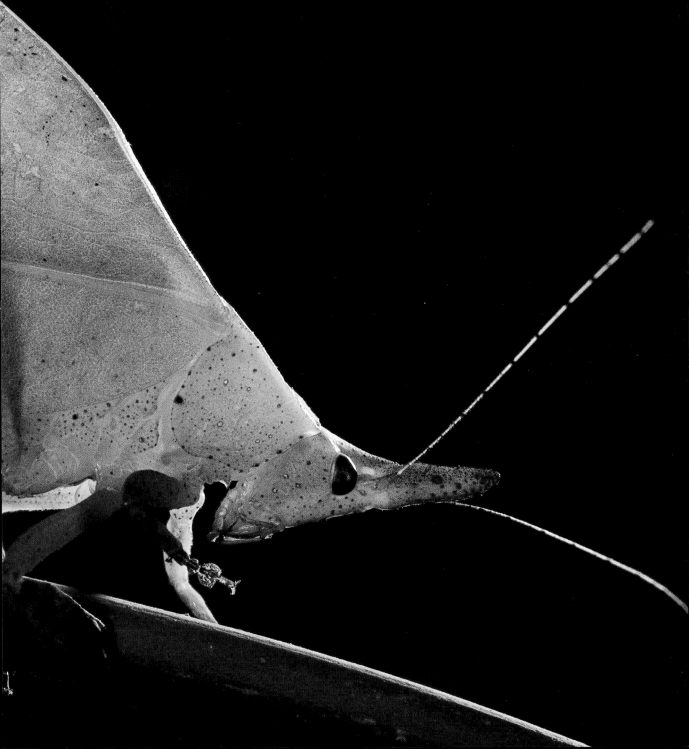

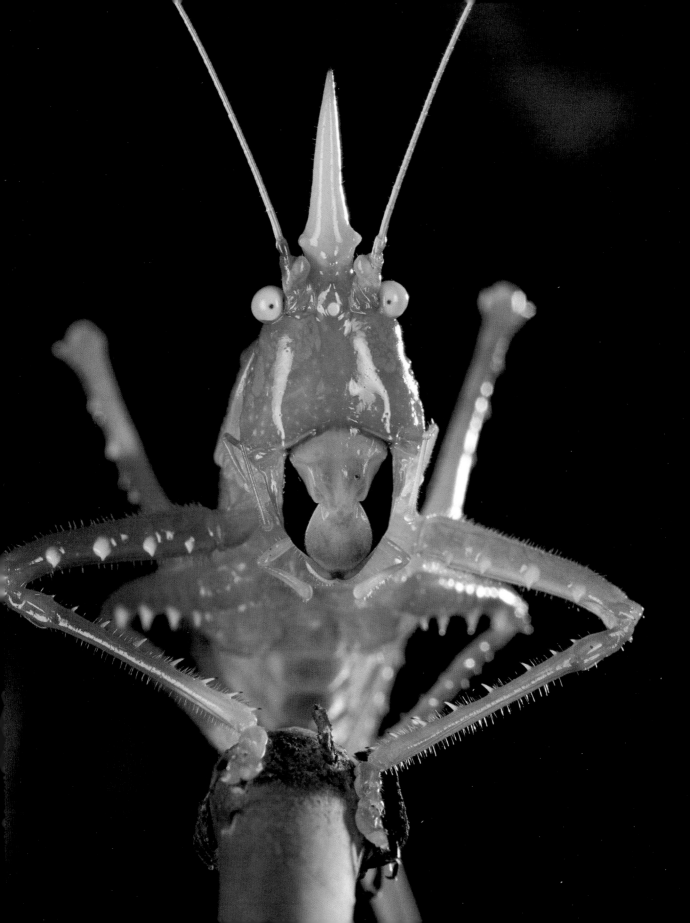

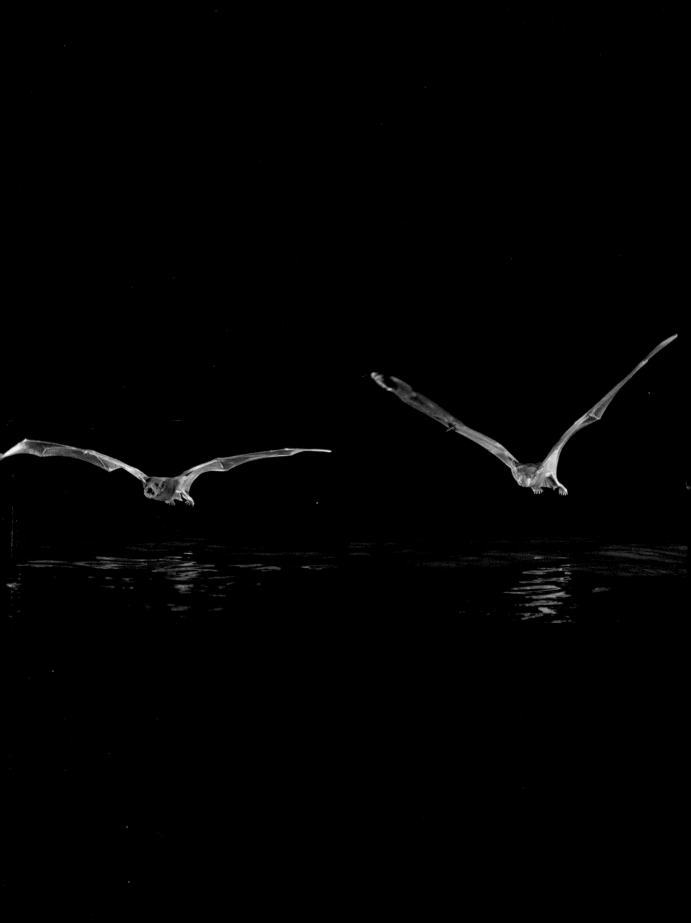

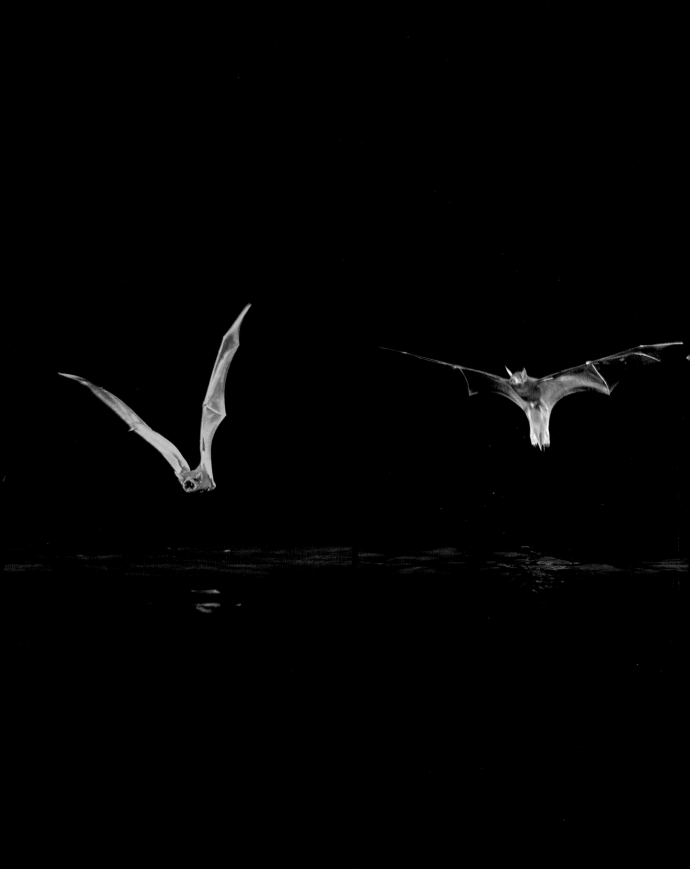

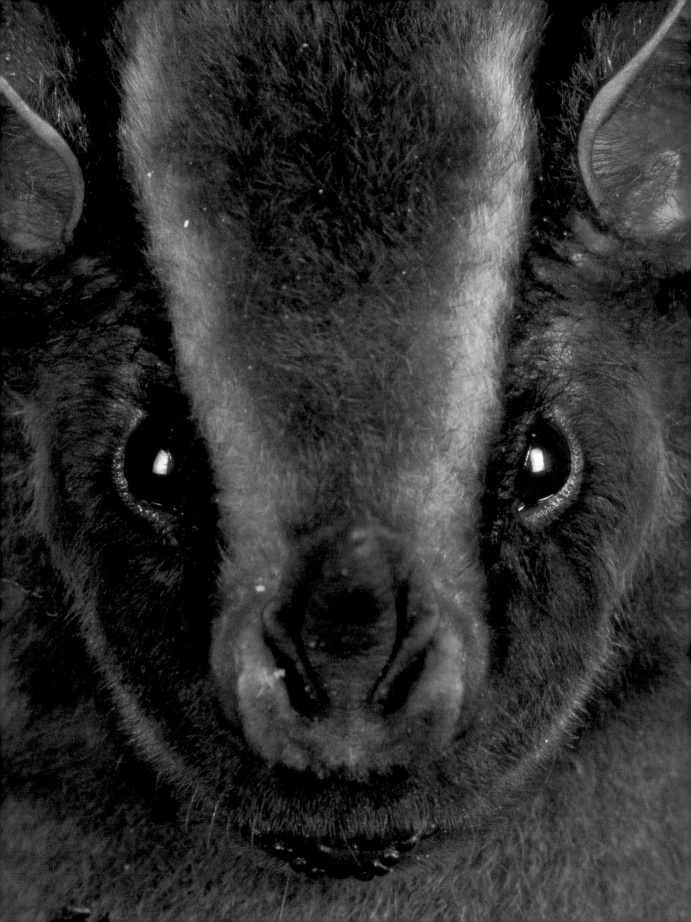

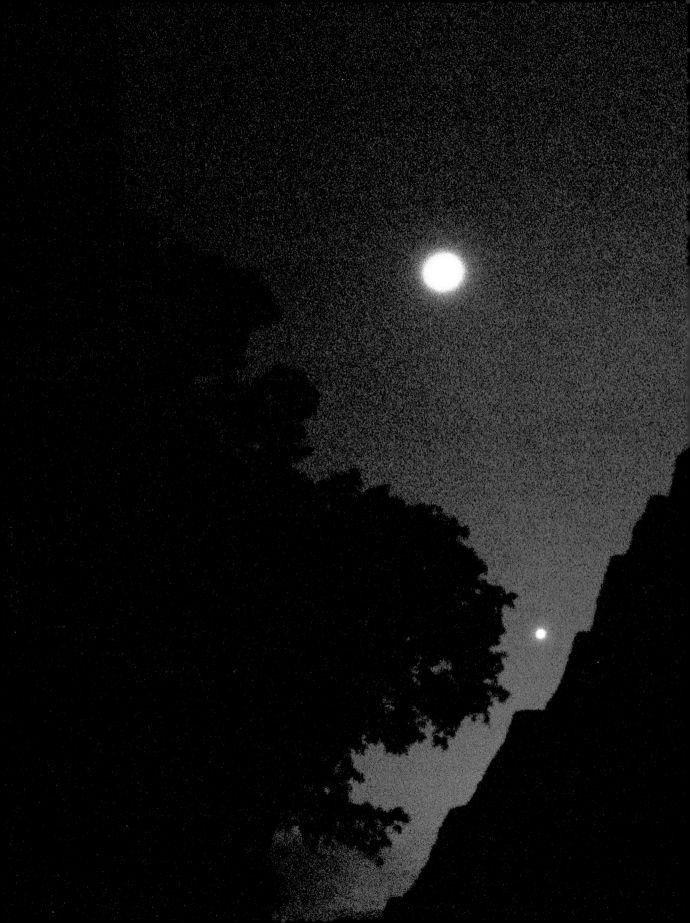

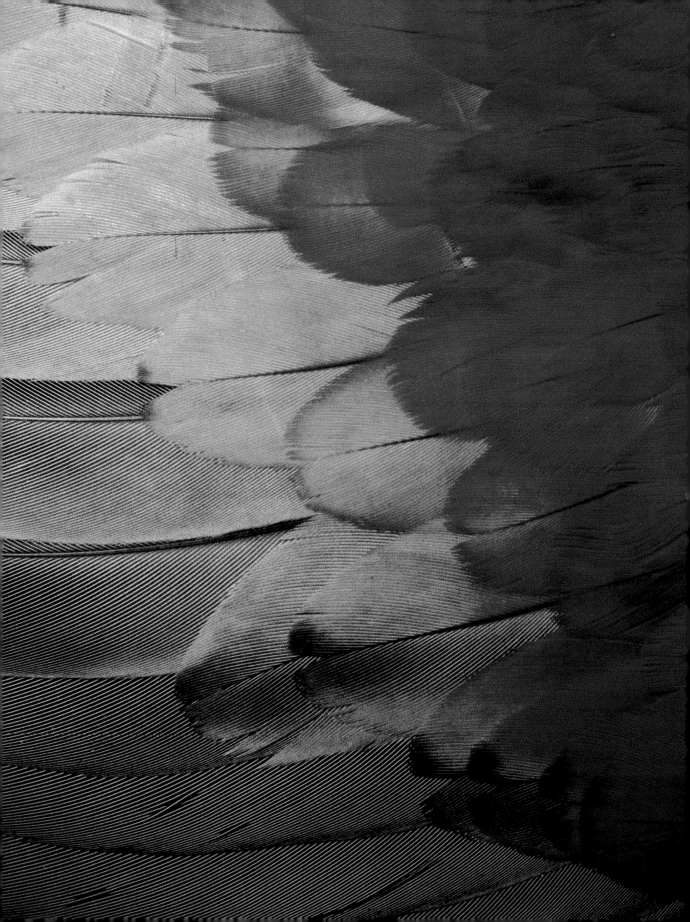

COLOR + CAMOUFLAGE

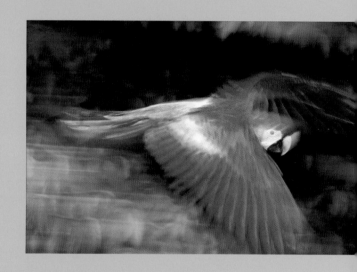

The air was filled with countless flamingoes and other water-fowl,

which seemed to stand forth from the blue sky like a dark cloud in ever-varying outlines....

In front of the almost impenetrable wall of colossal trunks of Caesalpinia, Cedrela, and Desmanthus,

there rises with the greatest regularity on the sandy bank of the river, a low hedge...

with gate-like openings....At sunset, and more particularly at break of day,

the American Tiger, the Tapir, and the Peccary, may be seen coming forth from these openings

accompanied by their young, to give them drink....

"It is here as in Paradise," remarked with pious air our steersman, an old Indian....

We passed the night in the open air, on a sandy flat, on the bank of the Apure,

skirted by the impenetrable forest....Deep stillness prevailed,

only broken at intervals by the blowing of the fresh-water dolphins.

Alexander von Humboldt, "Jungle River," *Views of Nature*, 1808

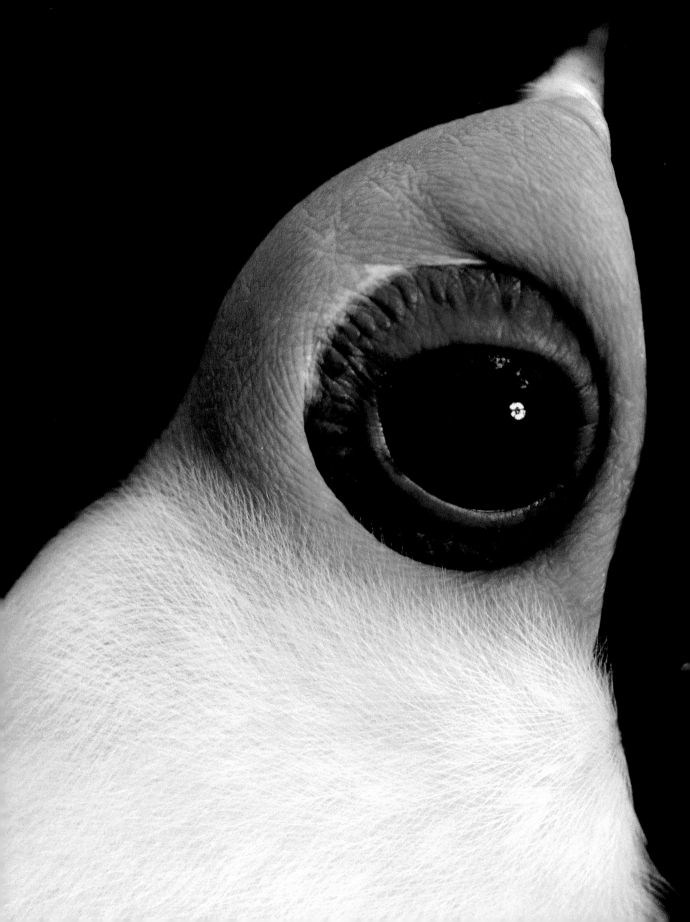

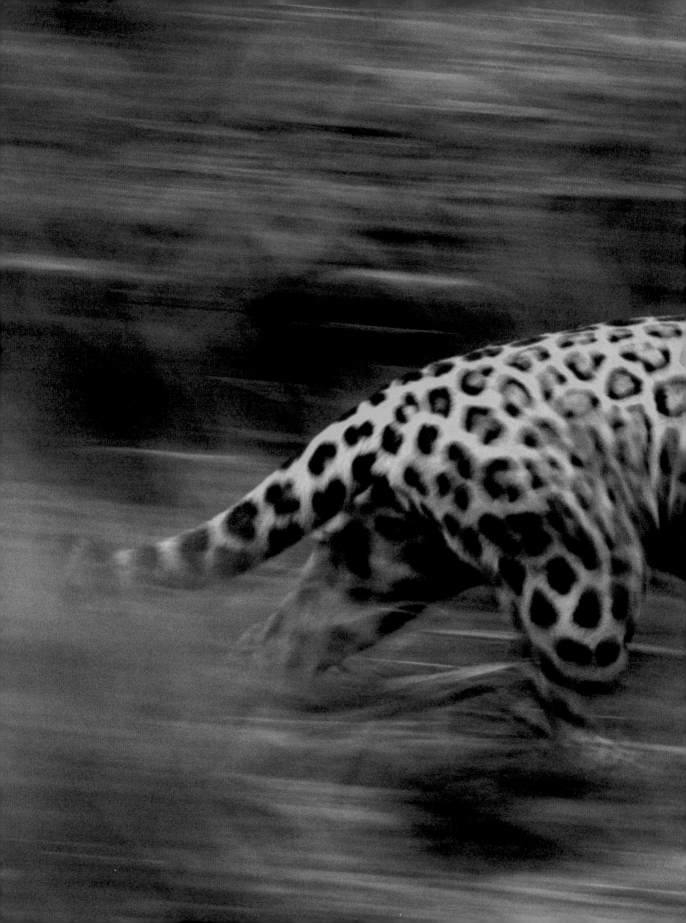

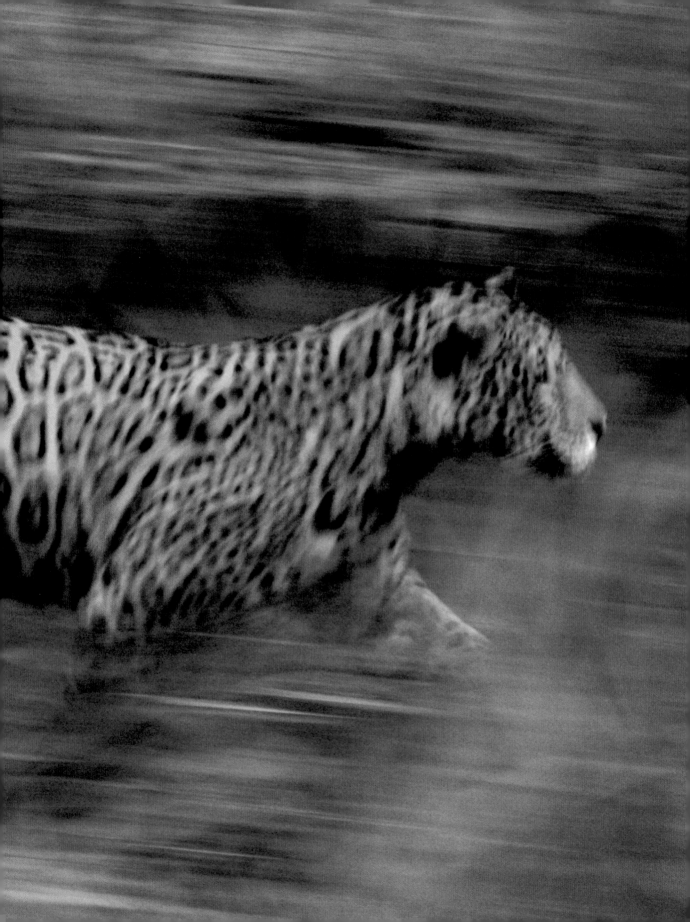

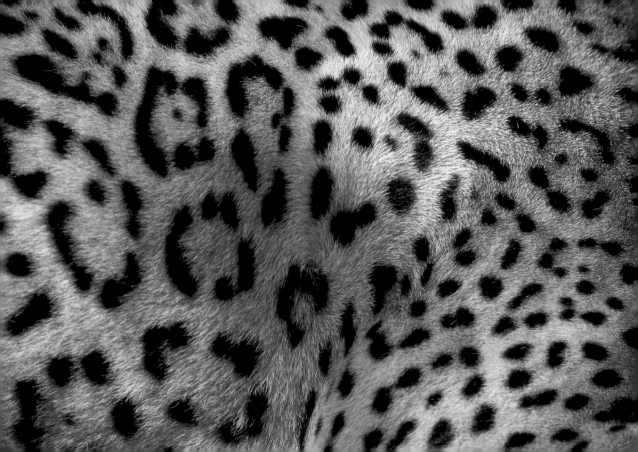

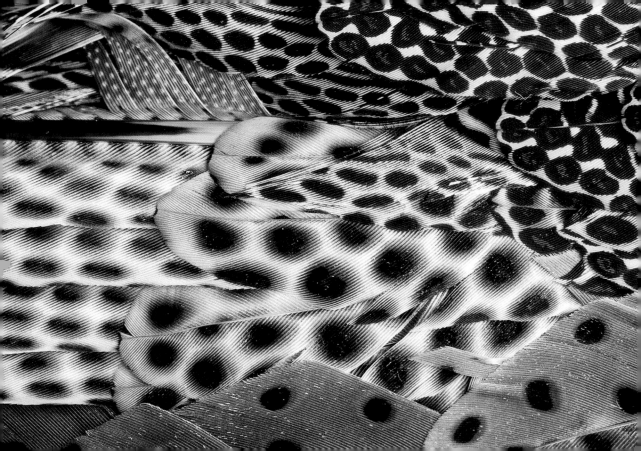

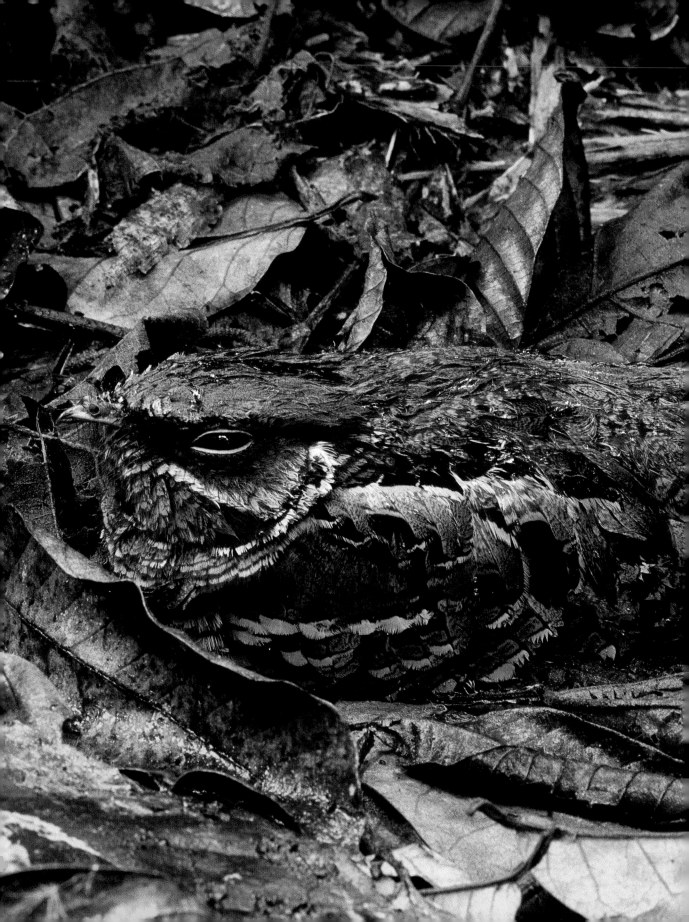

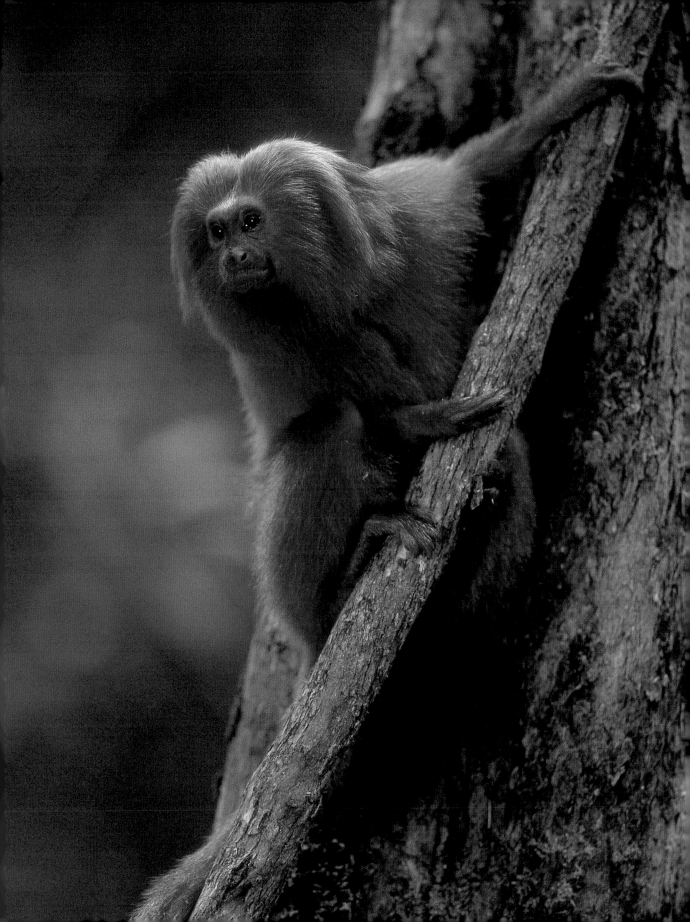

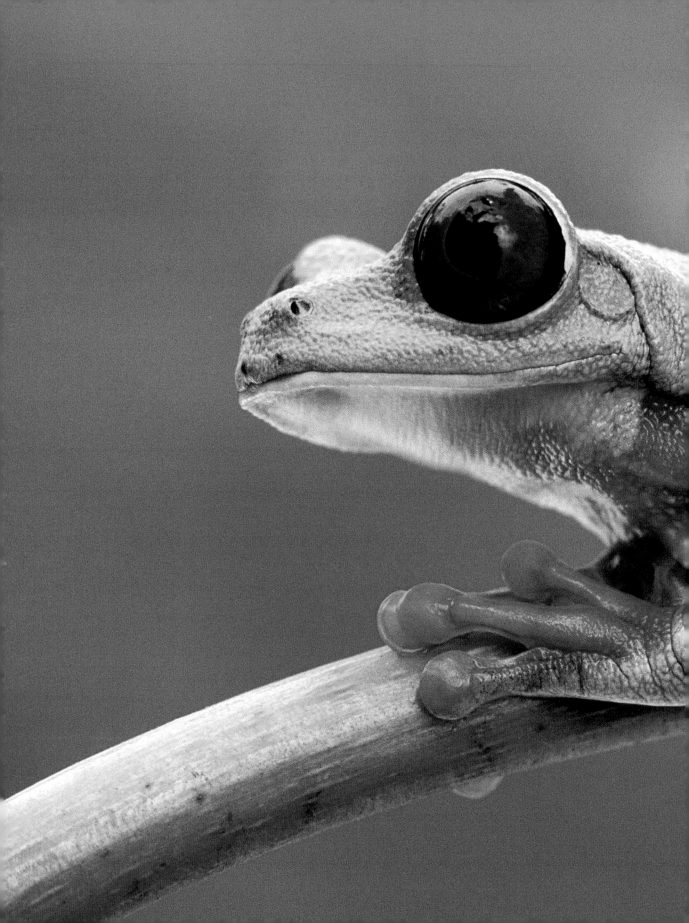

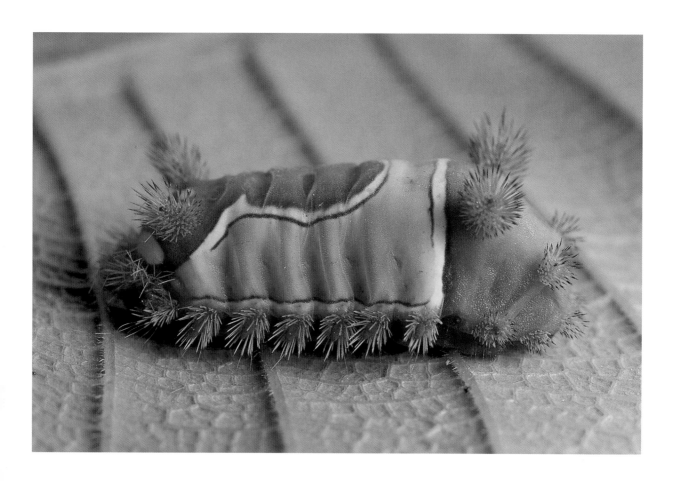

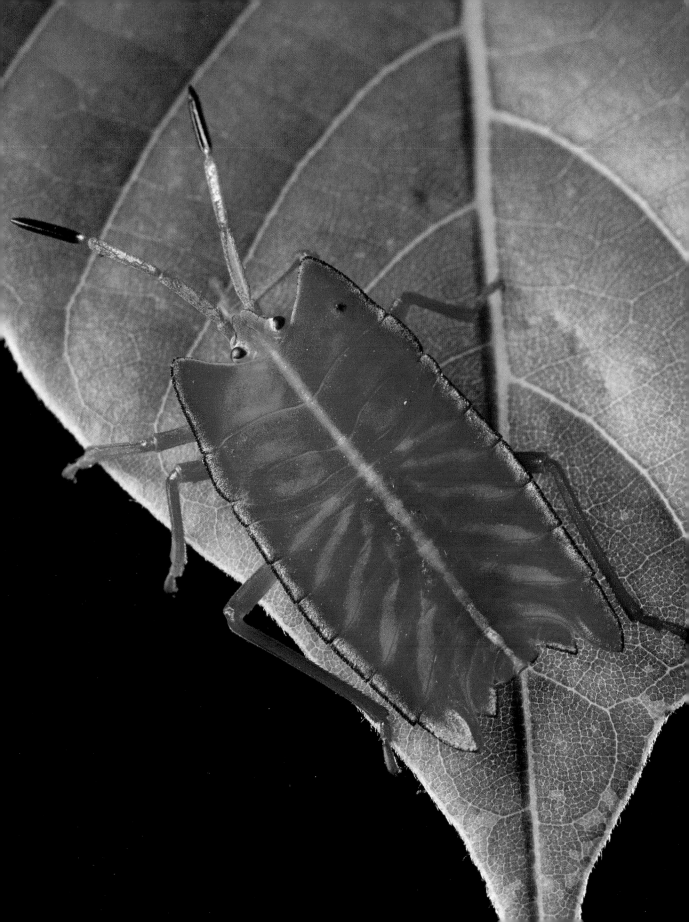

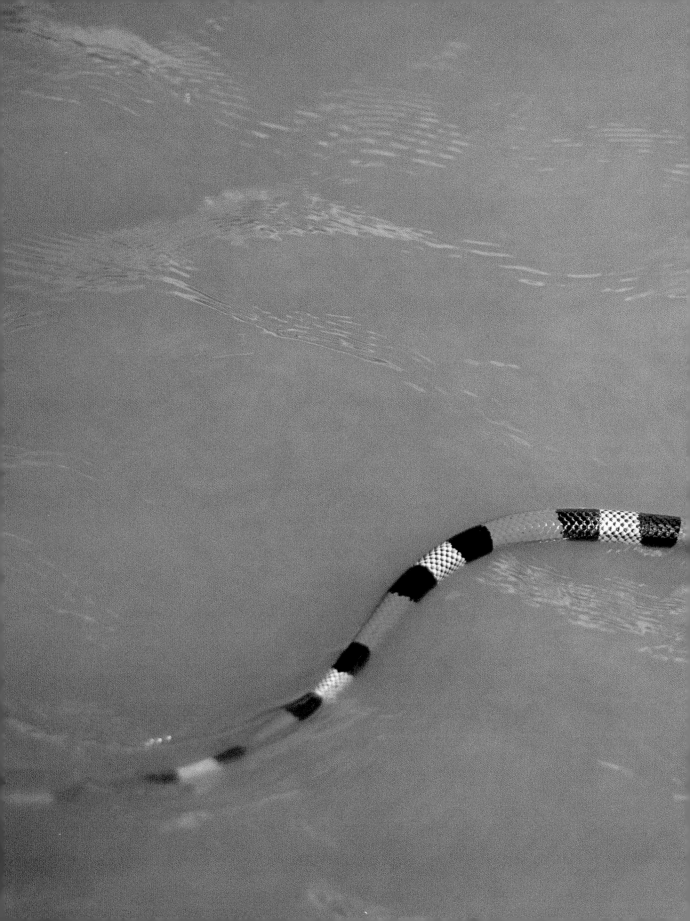

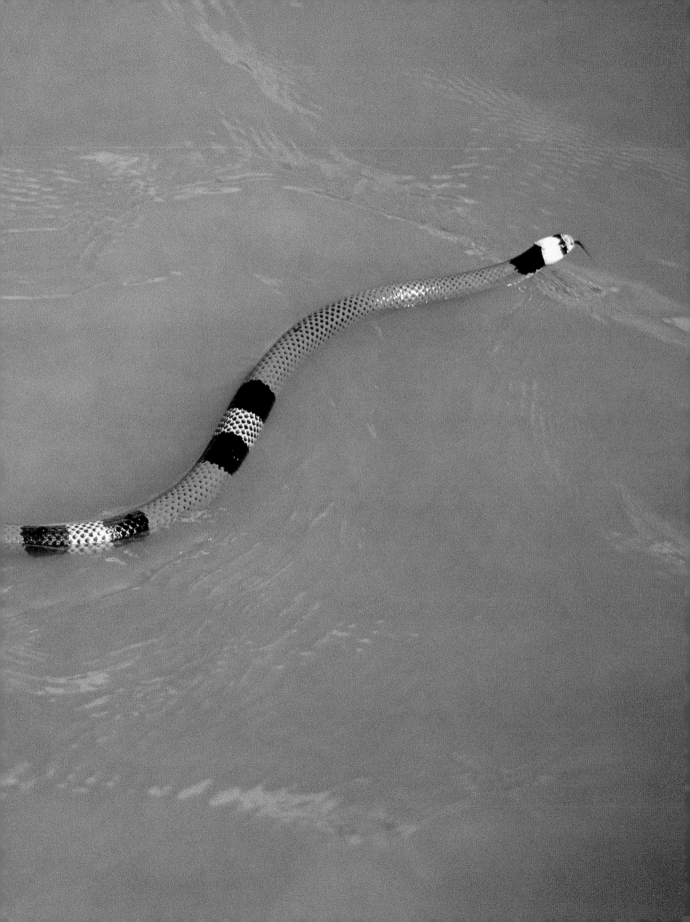

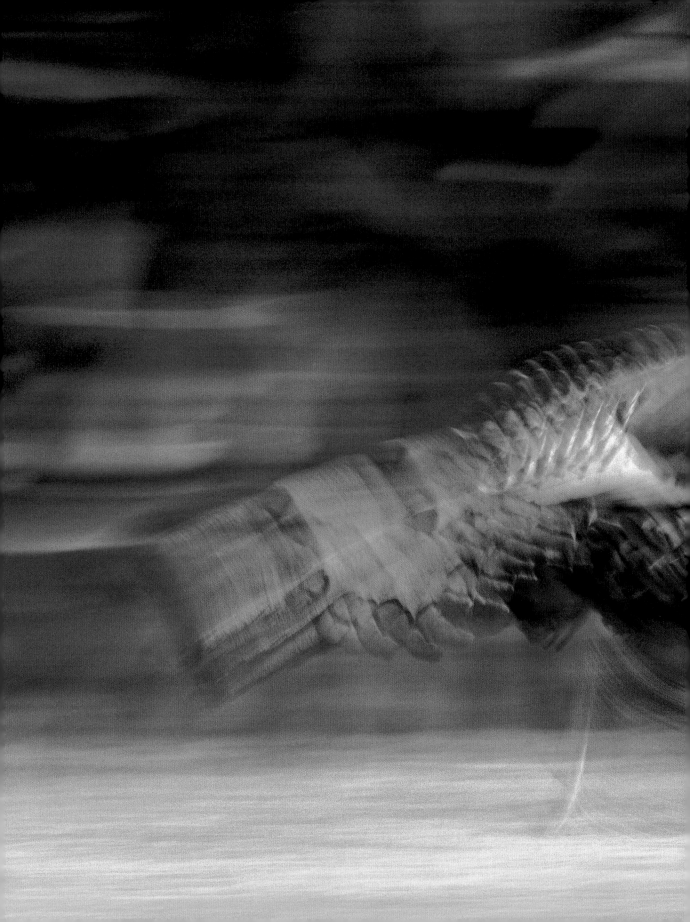

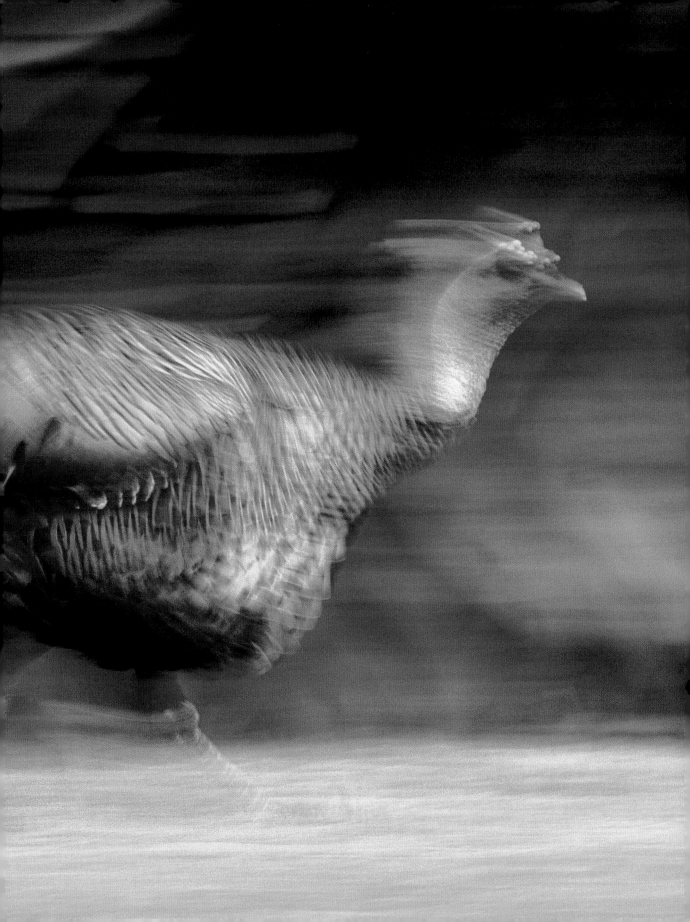

RIGHT: *Lichen Katydid, Borneo*
PREVIOUS PAGES:
PAGES 90–91: *Snake Crossing River, Peru*
PAGES 92–93: *Ocellated Turkey, Belize*
FOLLOWING PAGES:
PAGES 96–97: *Bonobo, Congo*

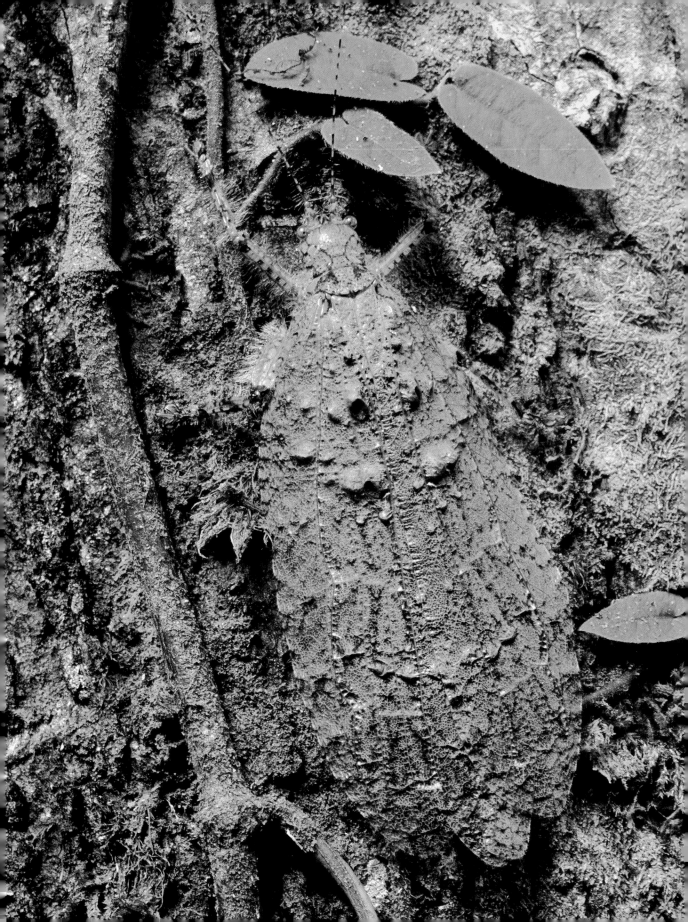

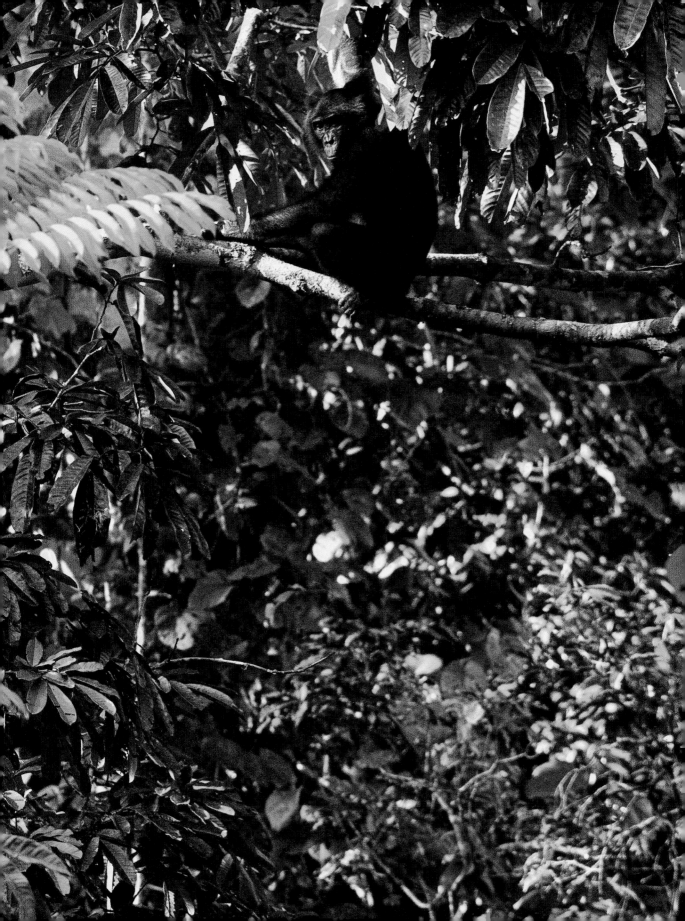

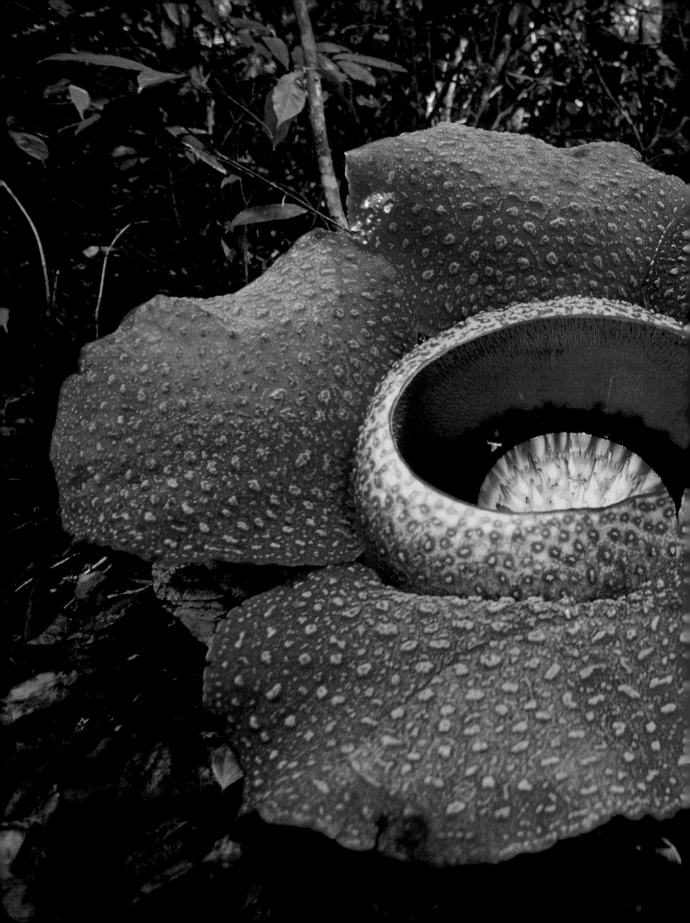

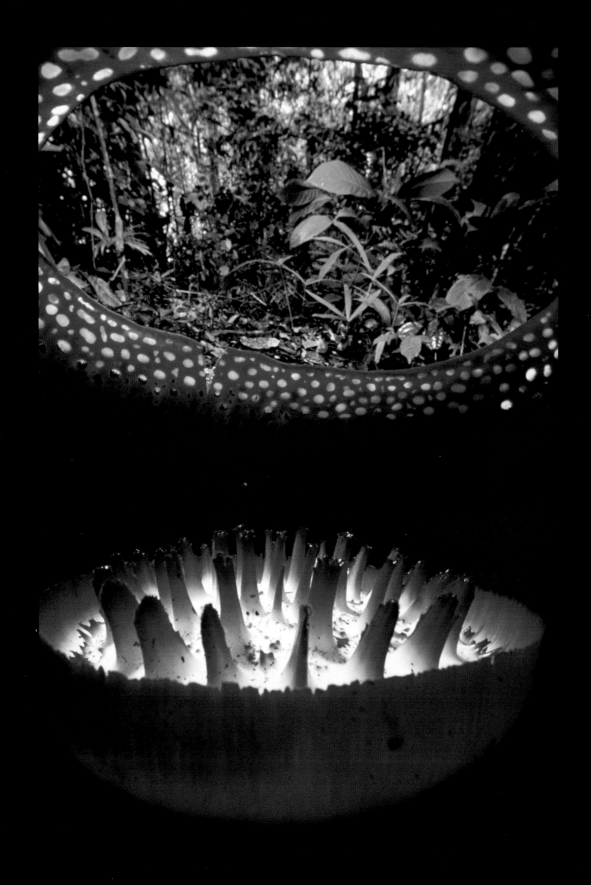

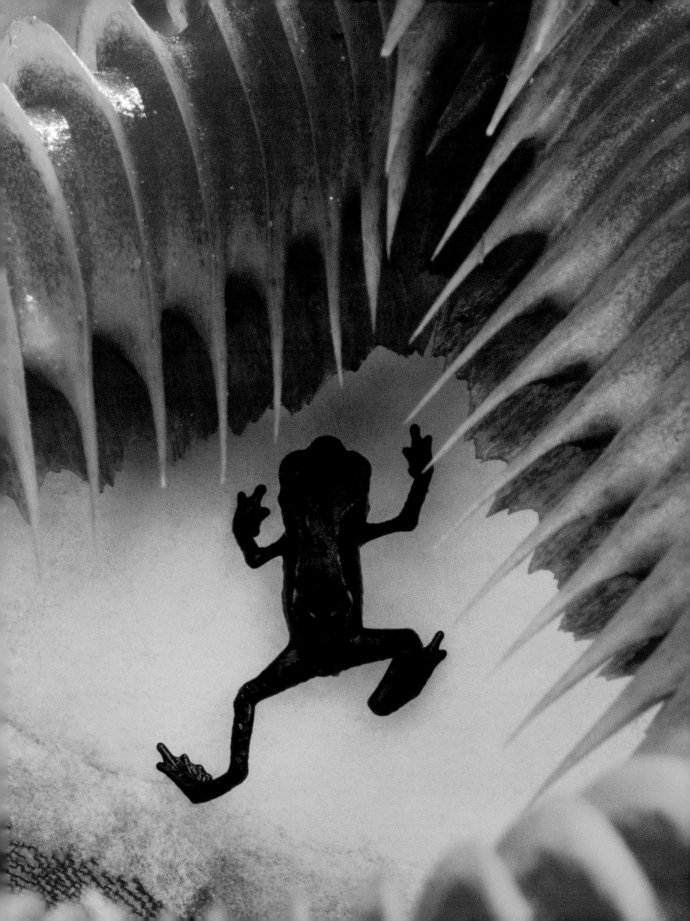

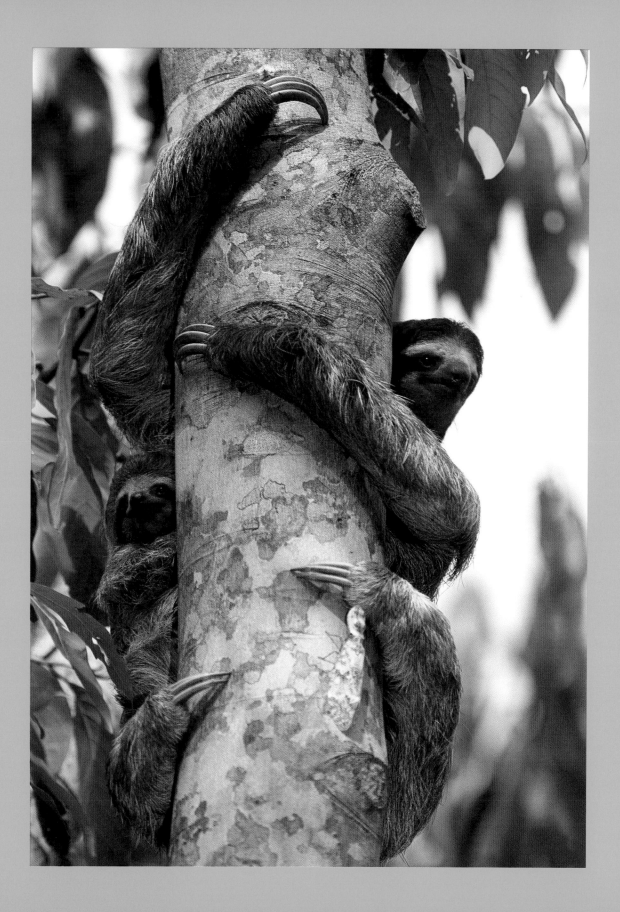

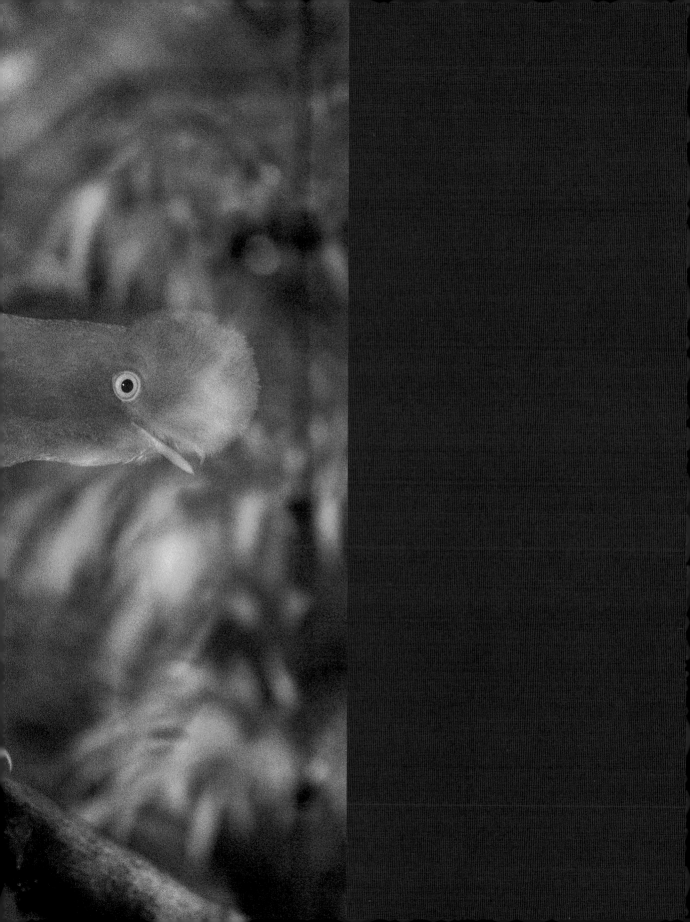

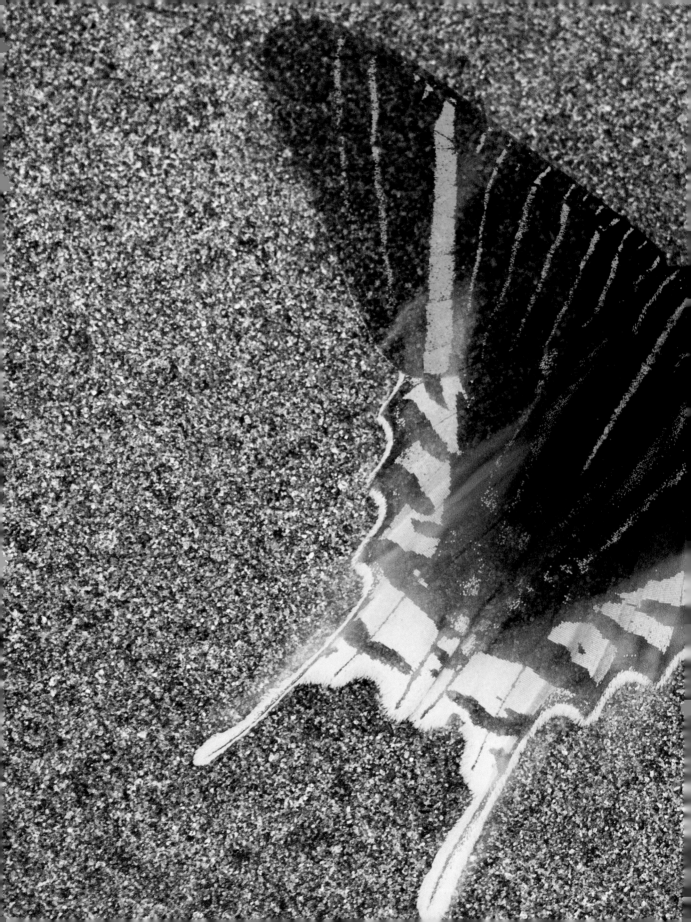

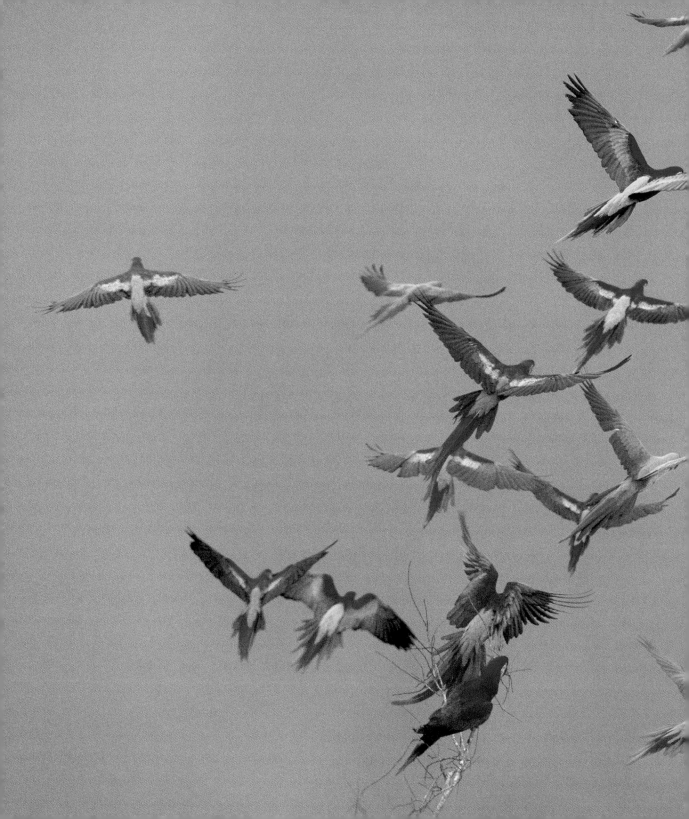

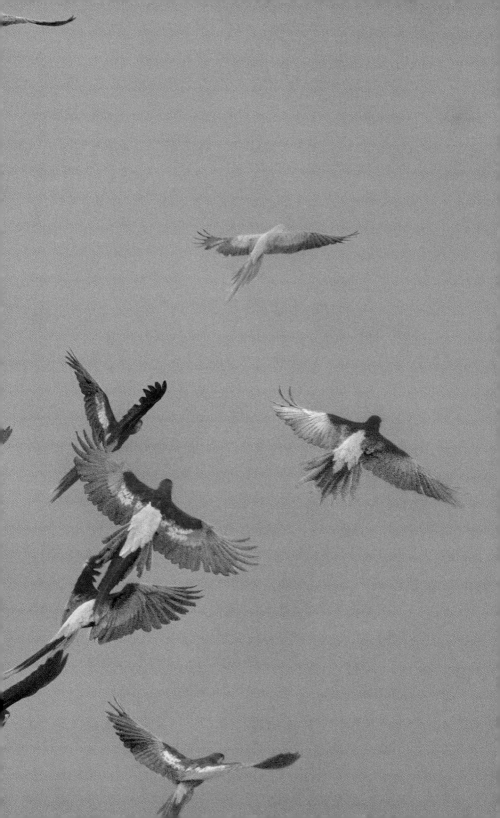

RIGHT: *Flowering Trees, Congo*
PREVIOUS PAGES:
PAGES 138-139: *Epiphytes, Borneo*
PAGES 140-141: *Cock-of-the-Rock, Peru*
PAGES 142-143: *Jungle Impression, Costa Rica*
PAGES 144-145: *Urania Moth, Peru*
PAGES 146-147: *Macaws over River, Peru*

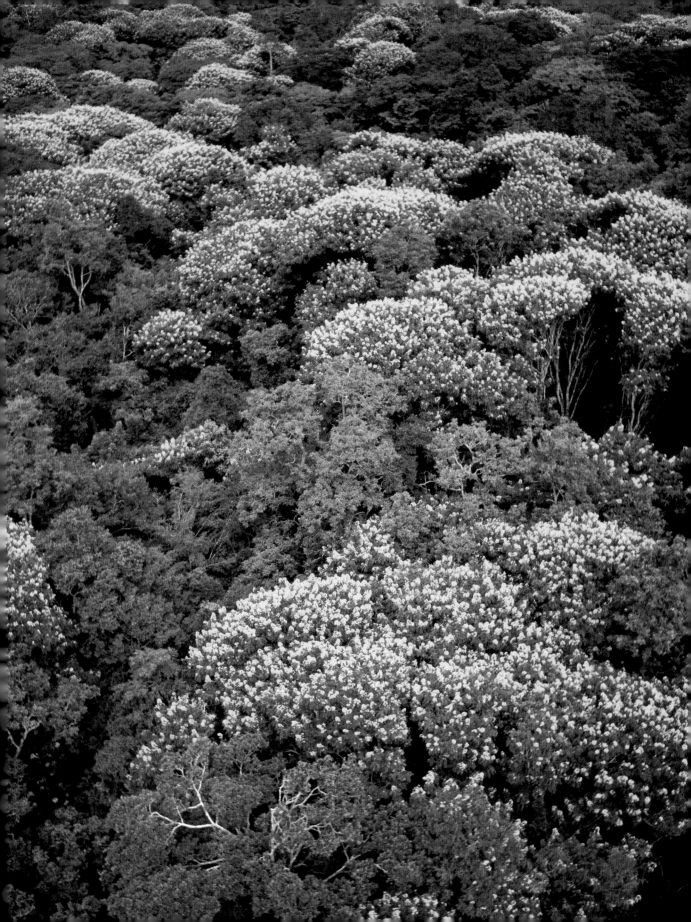

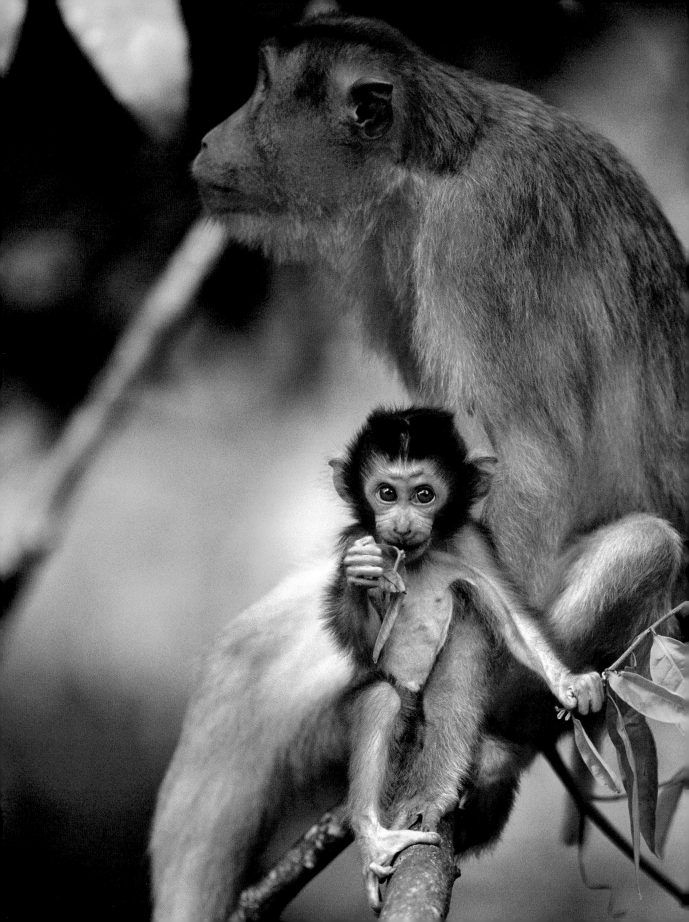

MOUNTAIN OF LIFE

I have never seen anything like it. A flower the size of a car tire that grows straight out of the earth. It glows like an orange apparition in the gloom of a rainforest on the lower slopes of Mount Kinabalu in northern Borneo. Ecologist Jamili Nais, who has led me here, is excited. He has measured this flower at three feet across and thinks it is one of the biggest specimens ever found of rafflesia, the world's largest flower. This outrageous bloom is the only visible part of a parasitic plant that consists of mere tissue strands inside a grapevine in the jungles of Southeast Asia. Rafflesia buds emerge from the vine and grow to the size of a basketball before they unfold five fleshy petals to form a flower.

Rafflesia is one of many botanical wonders that have brought me to Kinabalu, a mountain that rises 13,455 feet above the South China Sea—the tallest peak between the Himalayas and New Guinea. It is an isolated outcrop of granite that rose less than two million years ago and it is still growing. Kinabalu's dynamic geology and its location near the Equator have enabled a wealth of botanical diversity to take root. More than half of the world's flowering plant families are represented here, and of the plants that live above 4,000 feet on this mountain more than half are found nowhere else on earth. Plants with origins as far apart as China, Australia, New Zealand—even Europe and America—all thrive on Kinabalu.

Kinabalu's unusually compressed layering of life zones creates an opportunity to experience a rich sampling of the earth's flora in a journey of a day. From the coast of the South China Sea where I wake up one morning, Kinabalu rises like a fortress above the rest of the landscape. Clouds encircle the base of the mountain, enhancing its aura of inaccessibility. As I get closer, Kinabalu seems to grow higher, until it is hard to believe it can be climbed at all. I begin my trek on a steep trail that runs straight up the mountain like an endless staircase. As I climb, the overall diversity of flora and fauna decreases, but at different elevations new plant families appear. The trail winds through forests dominated by oaks and chestnuts which give way to groves of bamboos and tree ferns, replaced in turn by rhododendrons, tea trees, and pines higher up.

By the time I reach the cloud forest at 8,000 feet, there is a sharp chill in the air. At this elevation fog soaks the slopes. There is moisture in abundance to nurture the forest, but the soil is poor. Pitcher plants have evolved a solution to this problem. From the tips of their leaves they grow insect traps in the form of sweet-smelling pots with narrow necks and slippery walls. They are filled with enzymes that decompose the bodies of hapless creatures lured inside. The insects supply the plants with nutrients the soil cannot provide, but as I look inside some pitchers, I find there is a twist to

LEFT: *Macaque Infant with Mother, Borneo*

the story. Old pitchers fill with rainwater and become precious water reservoirs that serve as nurseries. Inside one pitcher I find a tiny toad, in another, the eggs of a snail. Pitcher plants are found in many tropical locations around the Indian Ocean, but no place on earth shelters a greater variety of them than this narrow band of cloud forest halfway up Kinabalu.

As I press on beyond the world of pitcher plants, the trees become stunted and the forest shrinks. This elfin forest features only a fraction of the species that live in the majestic jungles below, yet it is much harder to penetrate. The forest floor is a soggy mass of mosses entwined with epiphytes and roots seeking soil. There is no solid ground anywhere. It is at this elevation that Kinabalu's orchids are most abundant. In some places up to 90 percent of the ground cover is orchids, although most of the flowers are as tiny as grains of rice.

Above the elfin forest life thins out. At 11,000 feet I reach the tree line. Naked rock appears. Plants huddle together in crowded rock gardens, seeking shelter in crevices from the weather. I spend a cold night near the summit in a hut with sheet metal walls rattled by the wind. Before dawn I leave my shelter to complete the climb to the top. In a cave just below the summit a liverwort has taken hold. The only other places where this species of primitive plant grows are Alaska and Japan, and yet here it is, one of the many unexplained miracles of life on Kinabalu. When the sun rises it barely warms my face. From the summit I watch the light move down the slopes and illuminate the forest far below. The abundance of the tropical forest is only two miles away, and yet there is only ice and lifeless rock at my feet. I shiver as a cloud rises up the mountain to obscure all signs of life below.

TOP RIGHT: *Slipper Orchid, Borneo*
RIGHT: *Pitcher Plants, Borneo*
FOLLOWING PAGES:
PAGES 154-155: *Orchids, Borneo*
PAGES 156-157: *Crested Lizard, Borneo*
PAGES 158-159: *Orangutan Mother and Young, Borneo*

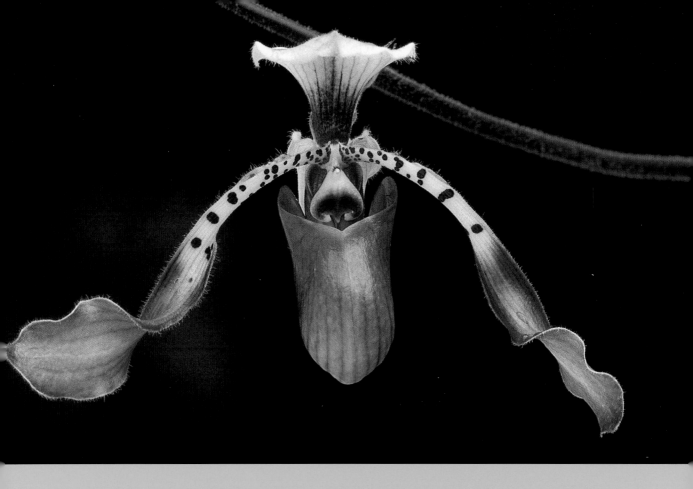

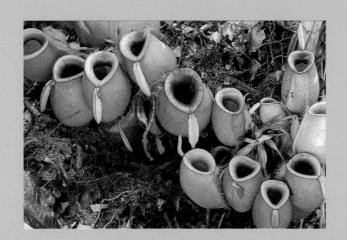

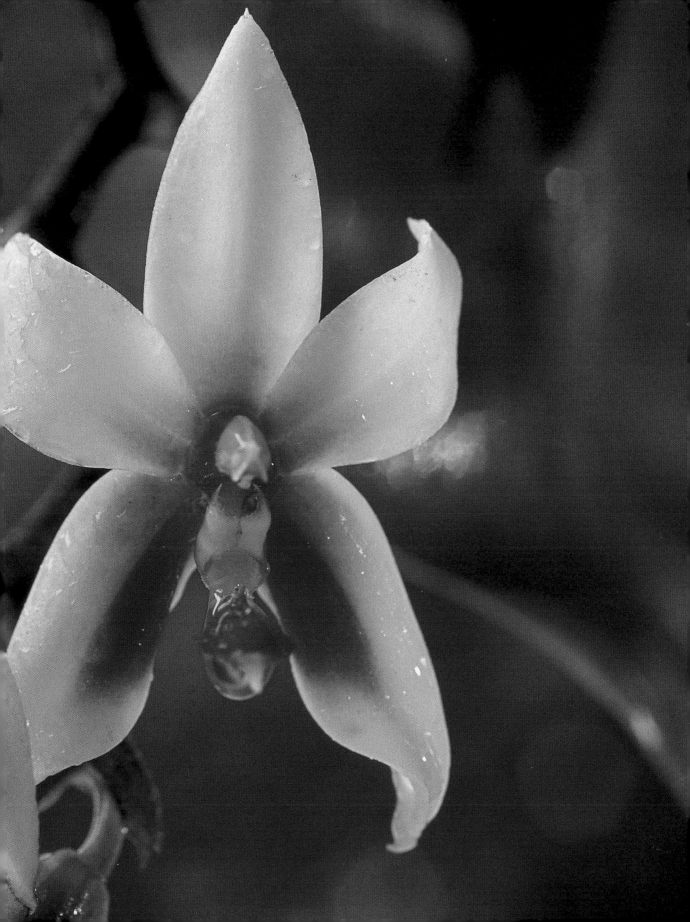

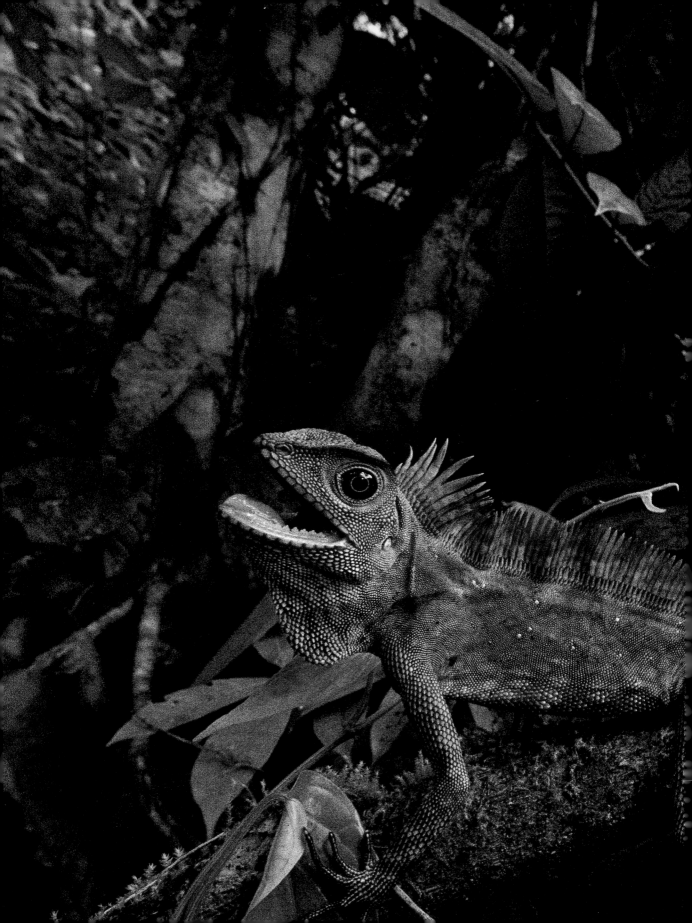

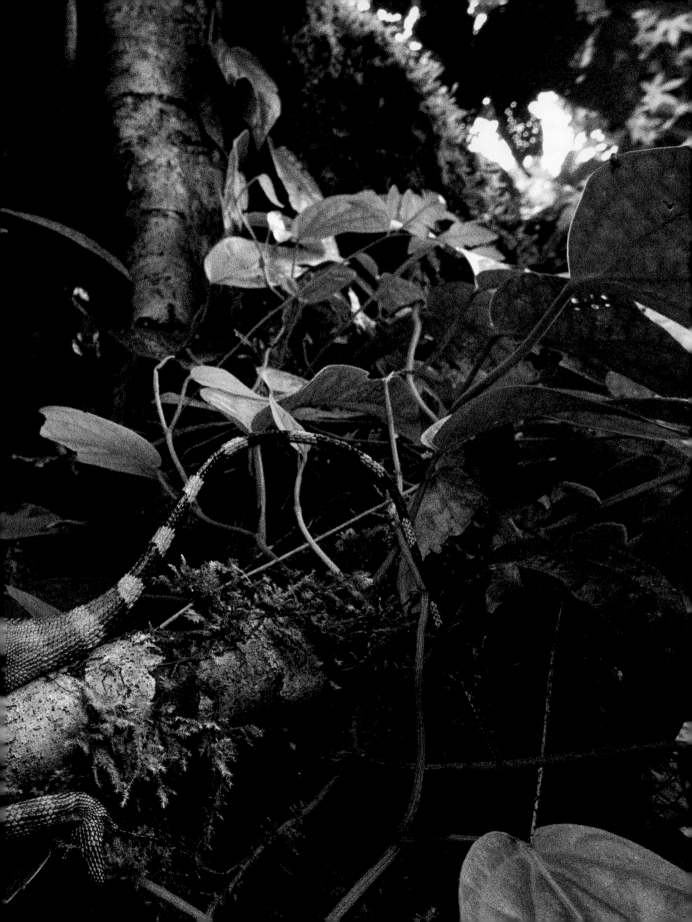

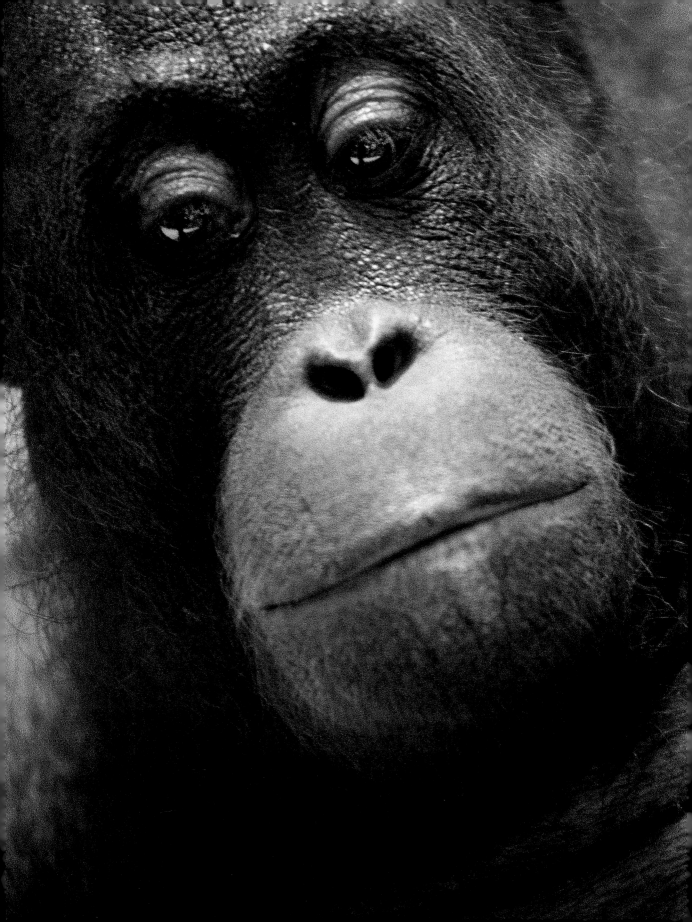

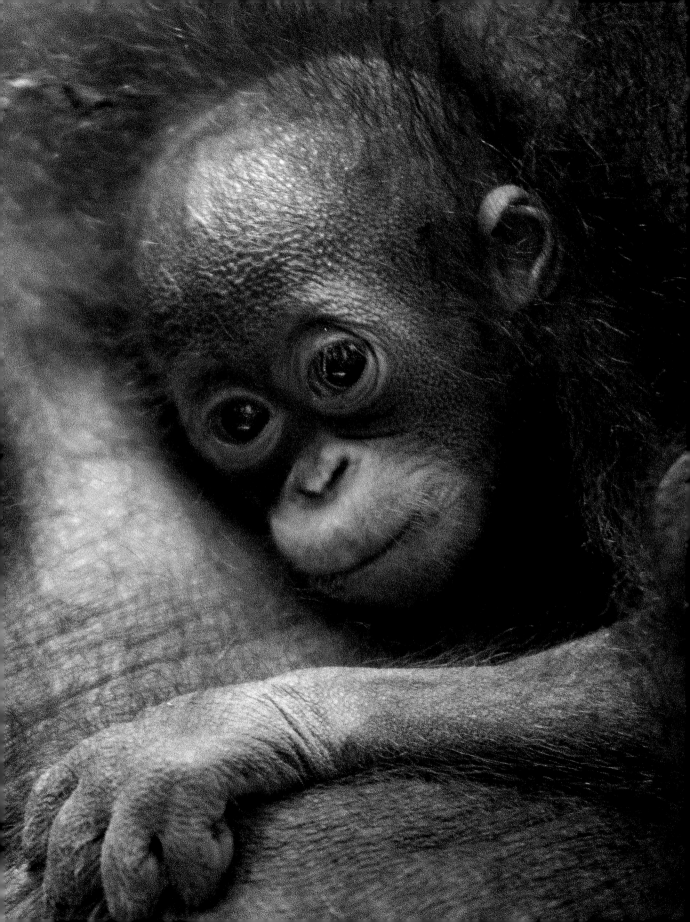

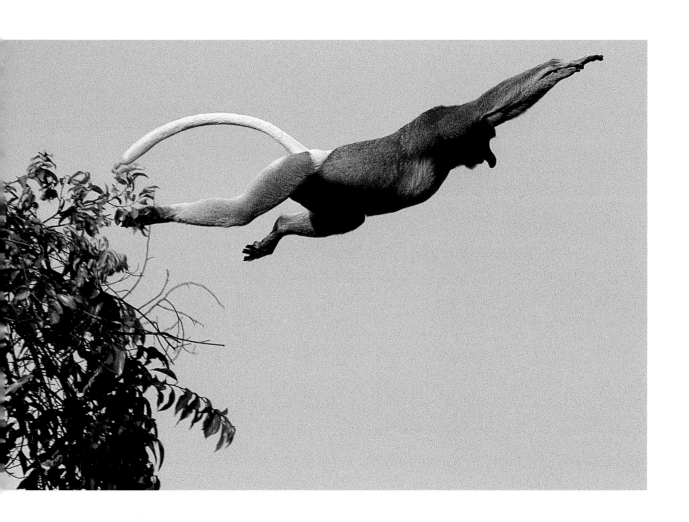

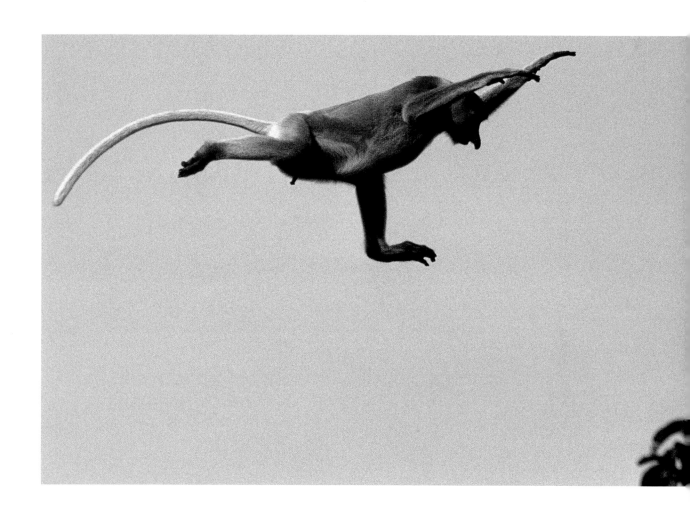

LEFT AND ABOVE: *Proboscis Monkey, Borneo*
FOLLOWING PAGES:
PAGES 162–163: *Lowland Forest, Borneo*
PAGE 165: *Sumatran Rhinoceros, Borneo*
PAGES 166–167: *Mount Kinabalu, Borneo*

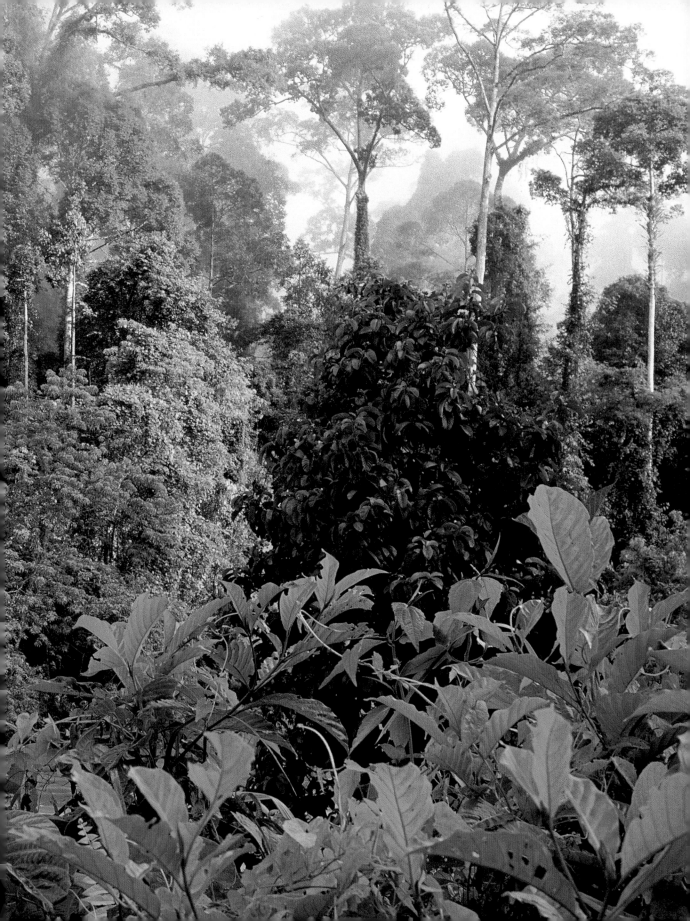

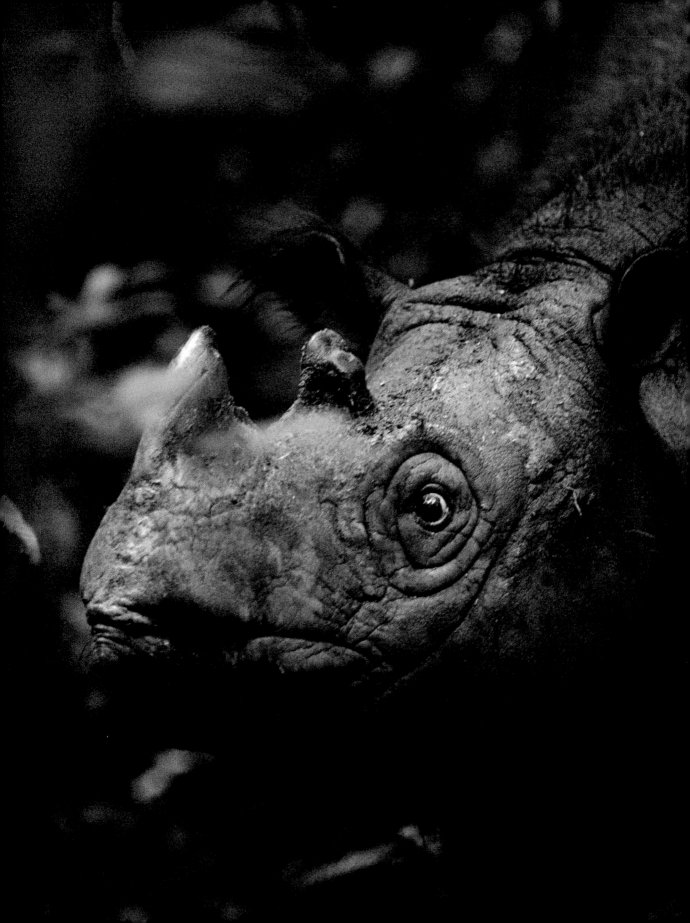

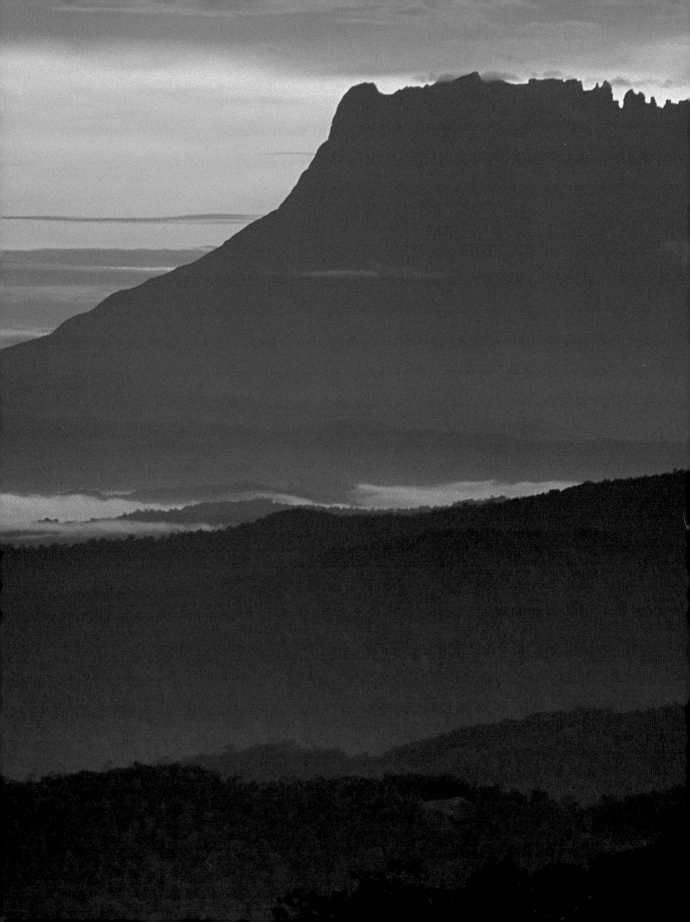

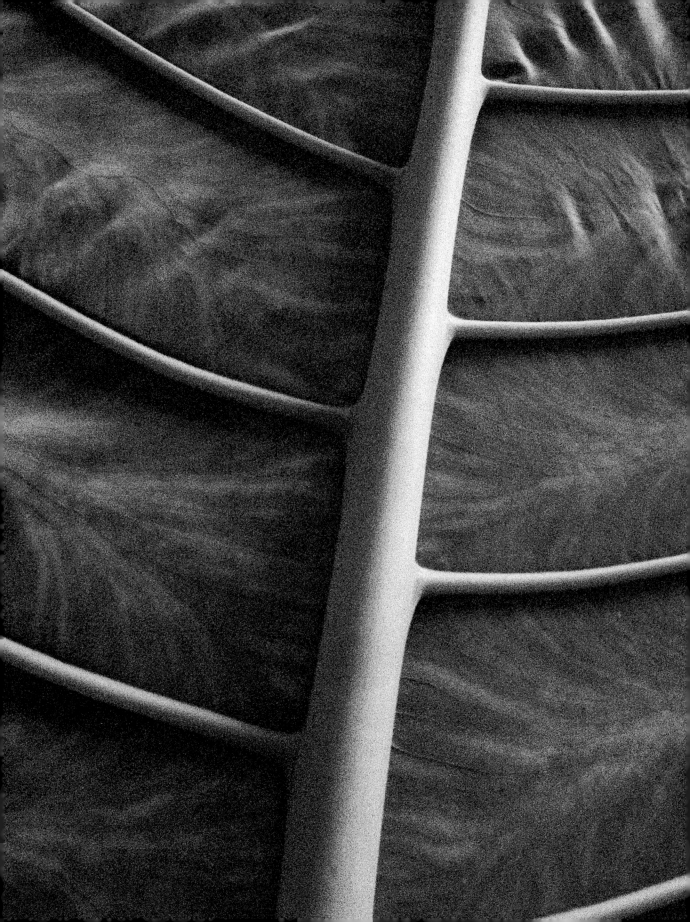

FORM + EVOLUTION

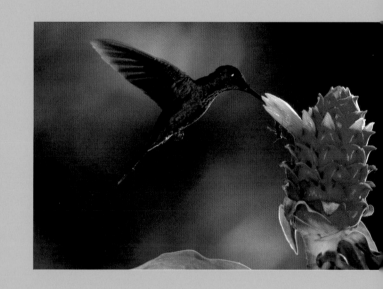

It is interesting to contemplate an entangled bank, clothed with many plants of many kinds, with birds singing on the bushes, with various insects flitting about, and with worms crawling through the damp earth, and to reflect that these elaborately constructed forms, so different from each other, and dependent upon each other in so complex a manner, have all been produced by laws acting around us.... There is grandeur in this view of life, with its several powers, having been originally breathed into a few forms or into one; and that, whilst this planet has gone cycling on according to the fixed law of gravity, from so simple a beginning endless forms most beautiful and most wonderful have been, and are being, evolved.

Charles Darwin, "Conclusion," *On the Origin of Species*, 1859

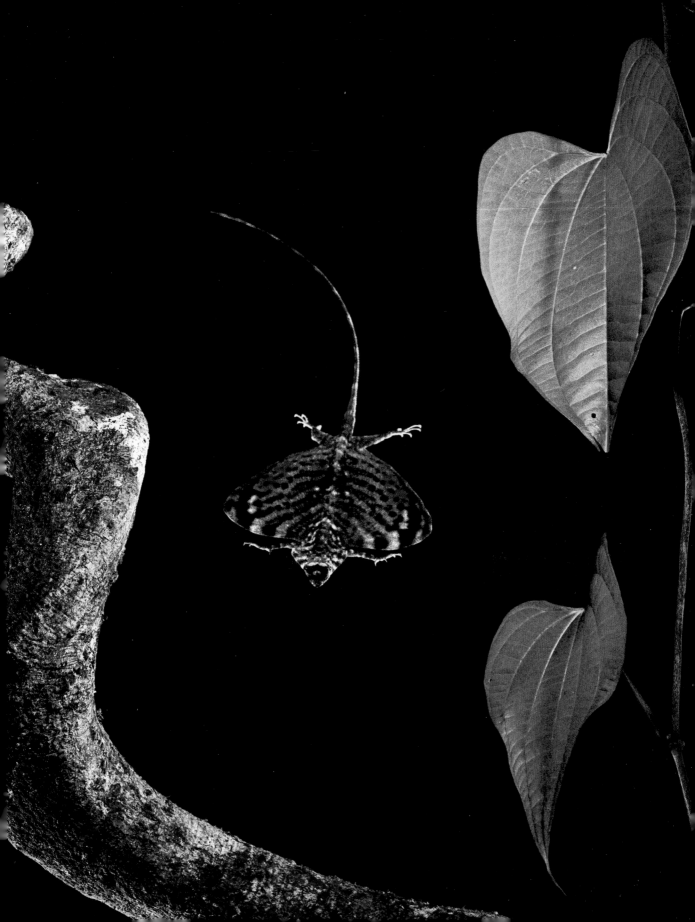

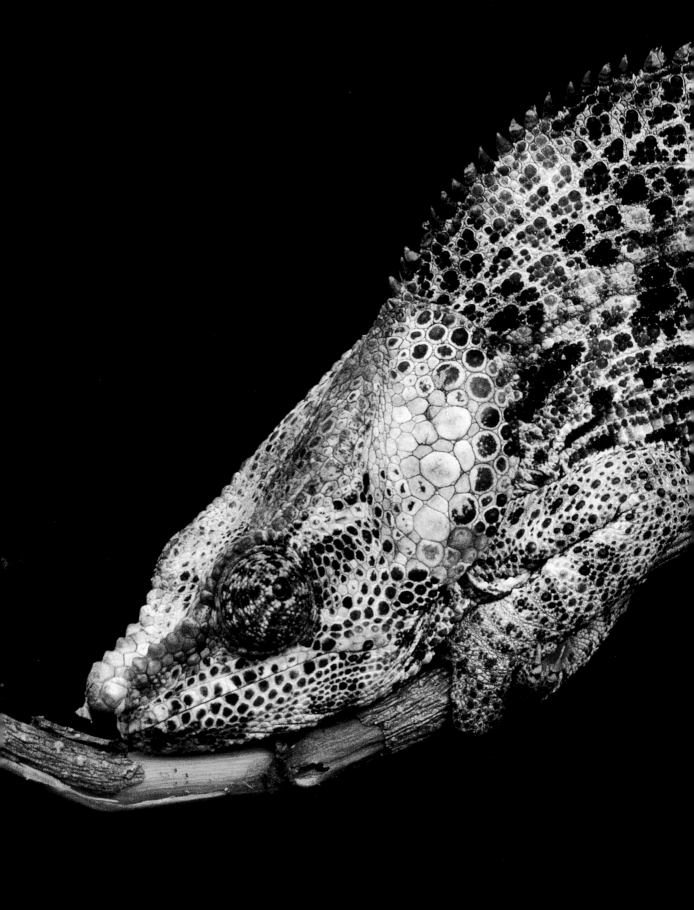

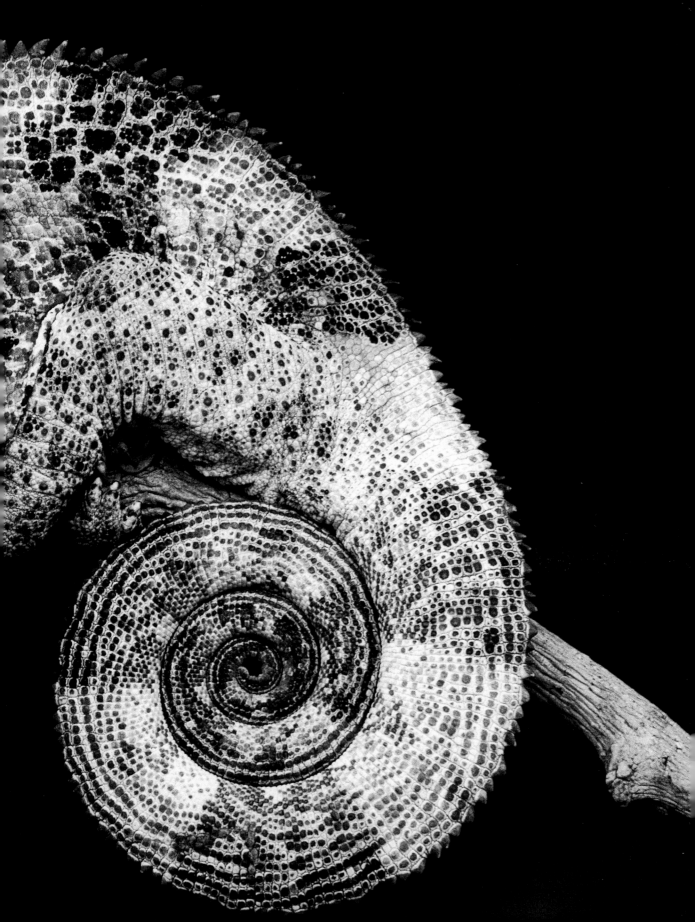

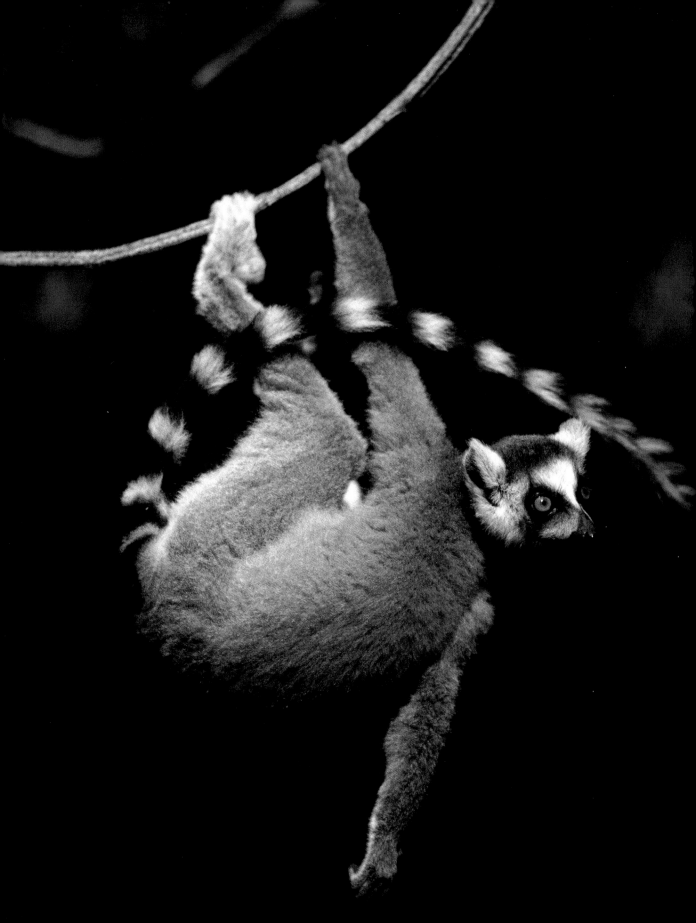

FACES IN THE FOREST

I have been haunted by a phantom animal. I came to Madagascar to look for lemurs, a family of primates found only on this huge island in the Indian Ocean. Most lemurs look like a cross between a monkey and a fox, but one, *aye-aye*, looks more like a ghost. Imagine a primate with ever-growing teeth like a beaver, leathery ears like a bat, staring eyes like an owl, a bushy tail, and long skeletal fingers. Aye-aye is an evil spirit, local people tell me. "You will go crazy if you look one in the eyes," claims one man. "You will get lost and never find your way home again," adds another. "Someone in your family will die unless you succeed in killing the animal on the spot," advises someone else. In the villages of eastern Madagascar, aye-aye stands for fear. When I ask about it, some people turn away. They do not even want to hear its name. I walk from village to village to find people who can help me track this elusive animal. Word of my interest spreads faster than my movements, and one day, when I walk into a village where I have never been before, I learn that I am known as "the man who searches for aye-aye."

Scientists have a different perspective about Madagascar's wildlife than local people, but they too have been baffled by aye-aye. It took them a hundred years to conclude that aye-aye was a lemur at all, because it bears so little resemblance to other lemurs—or to any other animal in the world. The secret to understanding this enigmatic creature is to consider the habits of woodpeckers. There are no woodpeckers in Madagascar, and aye-aye has evolved to fill that niche. Aye-aye primarily hunts for insects that colonize dead wood, listening with its big bat ears for the sounds made by grubs tunneling under tree bark. Then it chisels through the bark with its teeth and pries out the larvae with its elongated middle fingers.

Ever since Madagascar broke away from Africa 100 million years ago, its flora and fauna have been isolated from the rest of the world. Strange forms arose here over time. Lemurs filled a range of ecological niches not normally exploited by primates. Giant lemurs once grazed like cows in Madagascar's grasslands, because grass-eating animals like the antelopes of neighboring Africa never evolved here. The giant lemurs have vanished, probably because they were hunted by humans who colonized Madagascar 2,000 years ago. But more than 30 species of lemurs have survived. They range from frenzied little fruit-eaters the size of a mouse to the placid, ape-size indri, whose polyphonic songs resonate through the eastern rainforests. And there is one aberrant lemur with an unfortunate reputation.

When I begin my quest for aye-aye it is little known and considered nearly extinct. With the help of local people I search through forests in the foothills that rise from the Indian Ocean. We

LEFT: *Ring-Tailed Lemur, Madagascar*

find nests in which aye-aye sleeps during the day. I see its scratch marks on a tree trunk. Yet the animal itself remains invisible. But one day a farmer tells me he knows where aye-aye lives. I follow the man to his village in the hills, along a foot trail that winds through rice paddies and patches of forest. In his coconut grove he points to a pile of coconuts with big holes in their husks. They have been eaten by aye-aye, he says, and describes how the animal chews through the husk with its beaver teeth to make a hole through which it extracts the coconut flesh with its bony fingers. In a tall tree nearby I spot a nest. It looks like many other aye-aye nests I have seen, but when I approach, something stirs inside.

I have not moved from this tree all day. Now it is evening. I am lying on my back looking up at the aye-aye nest. I hear a faint rustle and switch on my flashlight. High above, through layers of leaves, I see the eerie face of aye-aye staring down at me. For a moment it looks like the embodiment of the villagers' nightmares. Then it becomes a sinuous shape that slinks away into the tree canopy without a sound.

TOP RIGHT: *Sifaka Family, Madagascar*
RIGHT: *Aye-Aye, Madagascar*

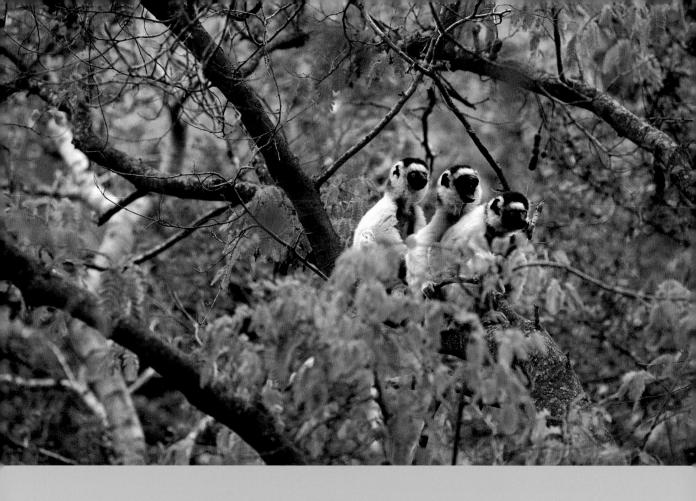

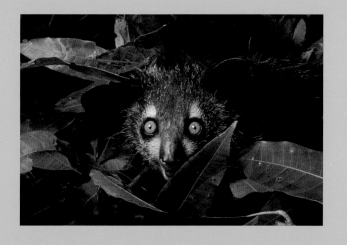

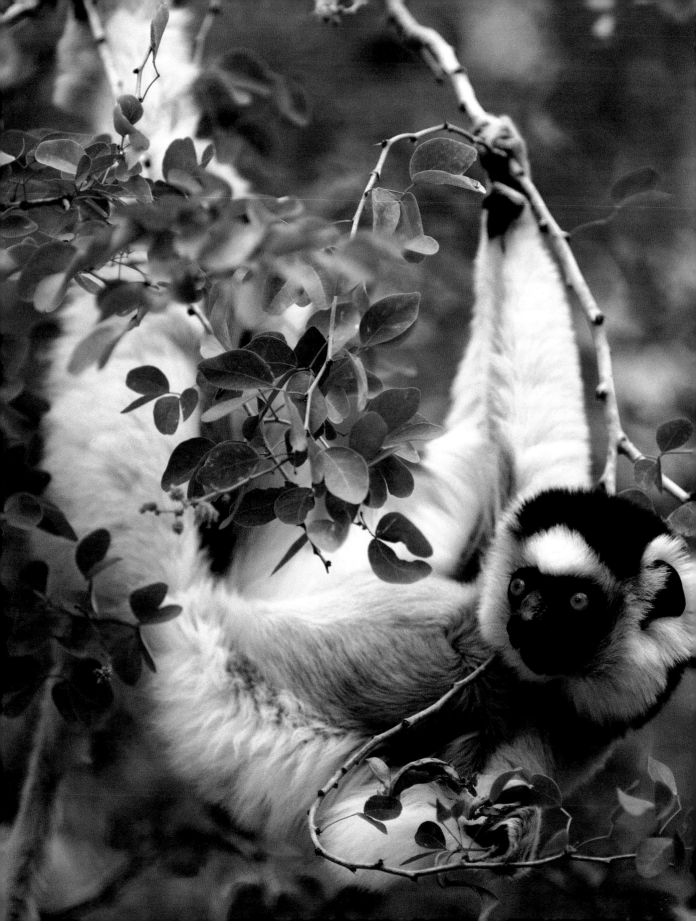

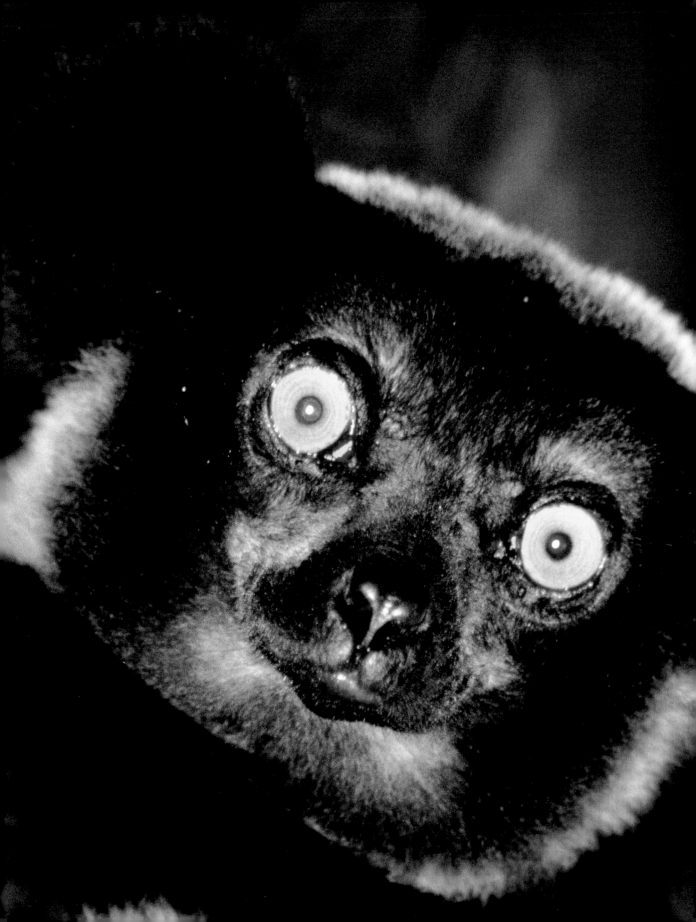

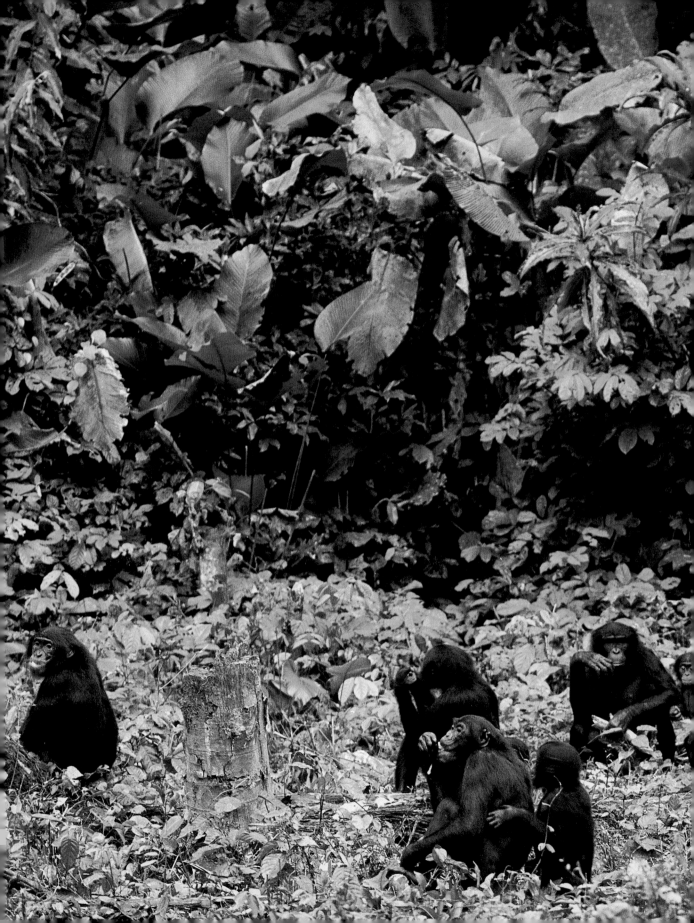

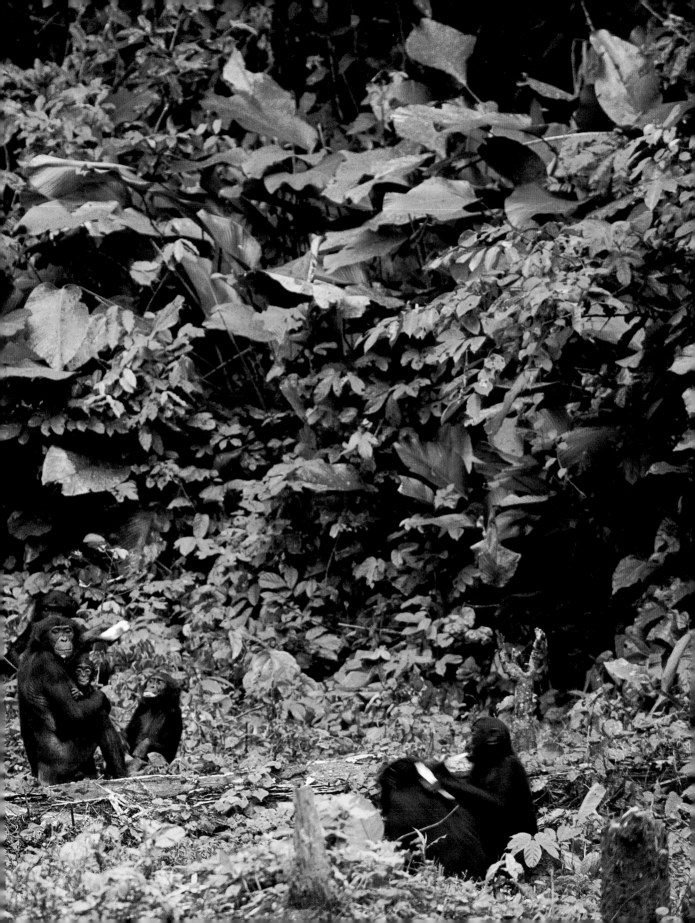

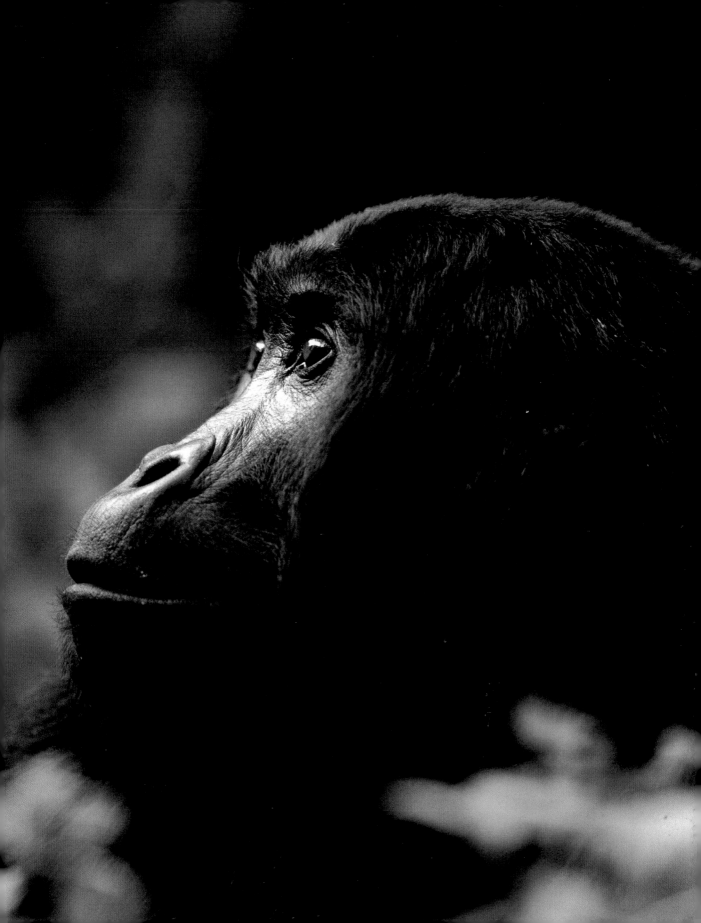

CAMERA IN THE JUNGLE

The tropical forest may be a naturalist's paradise, but for a photographer it can be a nightmare. Once you are inside it is all blood, sweat, and leeches. Whatever you take into the forest becomes part of the food chain, whether it is your equipment or yourself. I have seen leaf-cutter ants eat my tent, fungi grow in my lenses, and larvae emerge from the flesh of my leg.

Many of the wonderful things I have witnessed in jungles over the years have been impossible to capture on film either because the light was too low, the contrast was too high, or my lenses were fogged by high humidity. To me jungles present the ultimate test of camera equipment and photographic ingenuity. I pack my gear in hard plastic Pelican cases that carry padded LowePro backpacks during transport. Once I am in the forest I move around with the packs, and the cases become airtight storage boxes in which my cameras and strobes can dry out overnight with the help of silica gel. (When the silica is saturated with moisture, I cook it in a frying pan.) This extends the life span of sensitive electronic gear,

but ultimately everything succumbs to the jungle. I have gone through as many as ten camera bodies during a three-month expedition. So I bring plenty of spares. All images in this book were made with 35mm Nikon cameras and Nikkor lenses ranging from 18mm to 800mm, complemented by an array of accessories from strobes to extension tubes. I use a variety of transparency films, especially Fuji's Velvia and Kodak's new Ektachrome emulsions. I push film frequently, sometimes because I have to, and other times for stylistic effect. Fill flash and high-speed film are often essential for photographing action under the adverse light conditions in the jungle.

Most wildlife in tropical forests is either shy, cryptic, or out of reach. In response, I have constructed a great assortment of hiding places and other contraptions over the years. I have tried everything from simple blinds made of saplings and foliage—modeled on the design of Pygmy huts—to a one-ton steel tower 100 feet tall which gave me a unique shooting platform in the forest canopy.

Sometimes I set up makeshift studios in the forest using portable strobes with reflectors to portray subjects whose subtleties would otherwise be invisible. In a few cases, botanical and zoological collections enabled me to show details of plants and animals impossible to photograph in the wild. To photograph jungle life active after dark, I developed a remote-camera system with multiple strobes and encased all components in weatherproof boxes. That system, too, fell to the jungle. An army of ants chewed through the wiring, causing a spectacular battery meltdown. After endless tinkering however, the system finally yielded a few precious glimpses of animals at night.

In the end, jungle work takes time. Tropical forests reveal their secrets slowly. While photographing in northern Borneo I walked the same trail in a lowland rainforest for weeks. At the end of most days I felt I had seen very little. But when I looked back at the end of my fieldwork, I realized that I had actually encountered many of the wonders that had lured me there. In one short stretch of 500 yards, I had witnessed frogs fly, gibbons sing, squirrels soar. Jungles are like that. You never see everything at once, and there is always more.

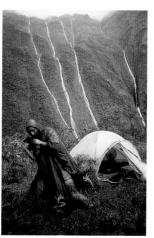
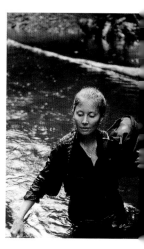

LEFT TO RIGHT: *Frans Lanting in the Congo; Treetop Blind, Peru; Inside the Blind, Peru; Frans Lanting and Christine Eckstrom on Floating Blind, Peru; Camping inside Wai'ale'ale Crater, Kauai; Christine Eckstrom in Borneo*

IMAGE INDEX

Dawn, Belize pp. 2–3
Morning mist blankets a tropical forest in the rugged Maya Mountains of Belize.

Flowering Tree, Borneo *Dipterocarpus* sp., pp. 4–5
First light strikes the crown of a flowering dipterocarp tree in a forest in northern Borneo. This family of trees dominates Borneo's jungles and is known for mass flowering and fruiting episodes which attract multitudes of animals from bearded pigs to orangutans.

Victoria's Crowned Pigeon <> *Goura victoria*, pp. 6–7
Filigreed feathers adorn the head of a male Victoria's crowned pigeon. This largest of the world's pigeons roams the forest floor in New Guinea. The absence of ground predators like the native carnivores found in other jungles may be the reason that this pigeon has evolved to the size of a goose.

Lowland Rainforest, Borneo pp. 8–9
A primeval forest in a narrow gorge in northern Borneo shows why some naturalists comparing the architecture of forests on different continents have called those of Southeast Asia the most majestic. Their stately appearance is accentuated by towering dipterocarp trees that reach heights of 200 feet. The lowland jungles of northern Borneo fit the classic definition of tropical rainforests, which exist in a ragged belt around the Equator, roughly between the Tropics of Cancer and Capricorn, in places where mean monthly temperatures exceed 75°F and at least four feet of rain falls annually.

Morpho Butterfly, Peru *Morpho deidamia*, pp.10–11
Morpho butterflies flash to be noticed. Their metallic blue wings have a mirror-like surface made up of tiny scales that reflect light more effectively than any known natural pigment. They coast through the dappled light of the forest in zigzagging flight patterns, flashing iridescent signals that can be seen over great distances.

Palms in Mist pp. 12–13
Palms belong to an ancient plant family that has become a symbol of the tropics. Many of the world's 4,000 species of palms are found in jungles, where they display forms ranging from spiny shrubs to feathery trees, such as this one I photographed in a botanical collection.

Scarlet Ibises <> *Eudocimus ruber*, pp. 14–15
My first search for scarlet ibises in the mangroves of Surinam led me into a never ending swarm of mosquitoes from which I emerged without ever seeing a single one of these intensely colored birds. They live along the muddy coast of northeastern South America, from the mouth of the Amazon north to Trinidad. Scarlet ibis color varies with the amount of carotenoids in the crustaceans they eat. Carotenoids are the same pigments that turn flamingos pink.

Forest Canopy, Costa Rica pp. 16–17
The forest canopy, shown here from a suspension walkway through a cloud forest, has long been inaccessible to scientific exploration. Naturalists since the time of Alexander von Humboldt have yearned to get up there, realizing it constitutes a separate biome. In the early 1800s Humboldt described it as "a forest above a forest;" a century later, American scientist William Beebe called it "another continent of life." Only in the past two decades is the canopy's amazing diversity of flora and fauna becoming known in detail to scientists. Canopy walkways and tree platforms designed for visitors now enable even more people to get up into the treetops.

Bonobo, Congo *Pan paniscus,* p. 18
It is impossible to look into the face of a bonobo without feeling kinship. I came face-to-face with this old male in the dim light of the Congo jungle. I had been following his group day after day for several weeks in a near-inaccessible region of central Africa, but encounters were usually distant and fleeting. One day I spotted him lying back on a log in a swampy area. He gave me a quizzical stare but then allowed me, for the first time, to come near.

Meandering River, Peru p. 20
Swollen with sediments from the foothills of the Andes, the Rio Torre flows through one of the greatest expanses of protected forest in the Amazon Basin, a system of national parks and reserves covering about 27,000 square miles—the size of the Netherlands and Belgium combined—along the border of Peru and Bolivia. This aerial view shows old river meanders becoming oxbow lakes, which shelter giant otters, caimans, and other creatures who favor still water.

Raindrops on Leaf, Peru p. 24
Rainwater is the lifeblood of jungles, though much of it is hoarded in the vegetation of the forest itself. It seems an irony that in an environment of high rainfall and an atmosphere that is supersaturated with moisture, standing water is often scarce. Many leaves are actually designed to shed water, which enables them to breathe more easily, absorbing carbon dioxide and releasing oxygen.

Morning Light p. 25
A shaft of sunlight reaches the understory of tropical vegetation in a botanical collection. Jungles need an intense level of solar energy for the photosynthesis that fuels the entire system. Yet less than one percent of the sunlight that beams down on the canopy touches the forest floor, where seedlings may wait years for an opportunity like a light gap created by a fallen tree before they can grow towards the sun.

Rainforest Sunrise, Borneo pp. 28–29
Water vapor rises from the forest overnight, like exhalations of breath. Humidity peaks just before sunrise, often resulting in a layer of mist. In this way the forest covers itself with a blanket of its own making, ensuring the greenhouse conditions essential to its existence.

Monsoon Rain, Borneo p. 30
After 23 straight days of monsoon rain pouring down on my camp in northern Borneo, nothing was dry. I squished wherever I walked; everything smelled like old sneakers. It is a common misconception that there are no seasons in the rainforest. Most jungles have distinct seasonal rhythms, but an average of four inches of rainfall a month is a minimum requirement to sustain a tropical rainforest.

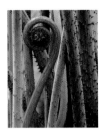

Fern, Borneo p. 33

A fern uncurls on a shady slope by a stream on Mount Kinabalu. Ferns are an ancient family that first appeared some 300 million years ago. Today their greatest diversity and numbers are found in Southeast Asia, where one-fourth of the 10,000 fern species live.

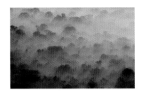

Morning Mist, Peru pp. 34–35

With an ultralight aircraft fitted with pontoons, I lifted off before dawn from the Manu River near the eastern foothills of the Andes to survey one of the world's largest intact tropical forests, Manu National Park and Biosphere Reserve, which extends from Andean cloud forests to Amazonian lowlands.

Frog in Mushroom, Borneo <> *Rhacophorus pardalis*, p. 37

"Frogs call the rain," according to an old Malay saying. Flying frogs like this one usually wait for rain to puddle in mud wallows created by rhinos before they glide down to the forest floor to mate and lay their eggs in the damp, semi-dark conditions that favor the reproduction of frogs and fungi alike.

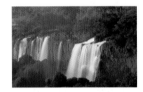

Waterfalls, Brazil pp. 38–39

On the border of Brazil and Argentina, the Paraná River plunges over Iguaçu Falls, carrying water draining from the center of South America.

Orchids, Madagascar *Angraecum* sp., pp. 40–41

A spray of ivory-white *Angraecum* orchids dangles above a stream in the forest of Ranamafana National Park. When Charles Darwin was shown a specimen of a related orchid with a nectar-filled spur a foot long, he predicted that its pollinator would be a moth with a proboscis to match. Although Darwin was ridiculed at first, entomologists 40 years later had to bow to his prescience when the hawk moth Darwin imagined was discovered in Madagascar.

Swimming Snake, Madagascar *Liopholidophis lateralis*, pp. 42–43

The sinuous motions of a swimming snake ripple a lagoon in Madagascar.

Capuchin Monkeys, Costa Rica *Cebus capucinus*, p. 44

At the end of the dry season in northwestern Costa Rica, water was so precious that a group of white-throated capuchin monkeys paid no attention to me sitting quietly nearby when they sneaked down to a puddle on the forest floor.

Giant Otter, Brazil *Pteronura brasiliensis*, pp. 46–47
Once widespread in the Amazon Basin, giant otters have disappeared from many major rivers because of hunting for their meat and skins. They now live primarily in isolated backwaters such as oxbow lakes, where they make their dens behind fallen trees and inside muddy tunnels under riverbanks. One way to search for them is to listen for their piercing squeals as individuals call to each other when they fan out on fishing forays across rivers and lakes.

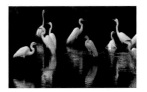

Great Egrets, Brazil *Ardea alba*, pp. 48–49
The serene impression of bathing egrets as I saw them through my viewfinder was a stark contrast to the conditions under which I made this photograph. While they were cooling off in the Pantanal's clear water, I was sweltering inside a canvas blind on a sun-beaten sandbar.

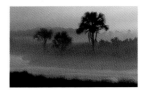

Palm Savanna, Brazil pp. 50–51
Throughout the center of South America, tropical forest mixes with stretches of savanna in areas where the soil is too poor to support continuous forest. These savannas, such as this one in Emas National Park, are good places to look for the hunched shape of the giant anteater roaming among the palms and termite mounds in the early morning.

Caiman Eyes, Brazil *Caiman crocodilus yacare*, pp. 52–53
As the dry season advances in the swamps of the Pantanal, lagoons shrink and caimans gather to gorge on fish that cannot escape.

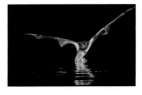

Fishing Bat, Panama *Noctilio leporinus*, pp. 54–55
Strobes illuminate a fishing bat as it strikes the surface of a lake along the Panama Canal. At night these fishing bats hunt for tiny fish and insects, which they scoop up and hold in a membrane stretched between their hind legs.

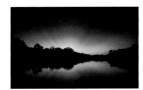

Evening Light, Peru pp. 56–57
Twilight in a tropical forest signals the transition from a visible world shaped by color and light to an acoustic realm that patterns the night.

Cloud Forest, Costa Rica p. 58
Where our eyes see a luxuriance of looping vines and lichen-draped boughs, the many species of bats who hunt at night using echolocation must navigate a landscape scientists characterize as a cluttered environment. Some bats specialize in hunting here beneath the canopy, dipping and swerving through the forest's obstacles to snatch insects and other small prey from vegetation.

Undergrowth, Costa Rica p. 61 (top)
A view from the ground shows an insect's perspective on the forest, and the damage some have inflicted on new leaves. Many insects like to hide on the underside of leaves, where they are less visible to birds and bats.

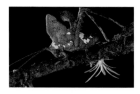

Dead-Leaf Katydid, Costa Rica *Celidophylla albimacula*, p. 61 (bottom)
Katydids are masters of mimicry. This one's dead-leaf disguise makes it less conspicuous to predators especially as it prepares to molt, a time of great danger for these insects, who cannot move until their new bodies harden.

Green-Leaf Katydid, Costa Rica *Aegimia elongata*, pp. 62–63
A small point on the head of this green-leaf katydid resembles the petiole of the leaf it mimics. During the day it presses its head against a branch and elevates its body, making this katydid look like a perfect leaf.

Conehead Katydid, Costa Rica *Copiphora rhinoceros*, p. 65
A bat-piercing horn works wonders for this katydid. One study revealed that bats rarely eat these coneheads, who defend themselves by raising their horns when they sense an approaching bat.

Fishing Bat, Panama *Noctilio leporinus*, pp. 66–67
Fishing bats hunt over open water just after dusk, echolocating through their open mouths to pinpoint the position of prey near the water surface.

Fruit Bat, Peru *Platyrrhinus* sp., p. 68
Caught in a mist net by a scientist on a soggy slope in the Andes, a fruit bat shows a face that is seldom seen. These bats are important dispersers of seeds; without them the regeneration of many trees in the forest would decline, and some species might disappear. By day these bats sometimes cling upside down inside tents they make of palm leaves. They chew through the central rib of a leaf until it folds down, forming a rainproof and light-proof shelter.

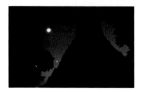

Moon and Venus over Maya Temple, Guatemala pp. 70–71
The Moon and Venus rise in alignment over an ancient temple at the jungle-covered ruins of Tikal, a Maya city that flourished early in the first millennium in the heart of Guatemala's lowland forest.

Wing Colors, Scarlet Macaw, Peru *Ara macao*, p. 72
The primary colors of red, yellow, and blue come together in a striking pattern on the upper wings of scarlet macaws.

Scarlet Macaw, Peru *Ara macao*, p. 73
A scarlet macaw flashes rainbow colors as he streaks through the forest canopy.

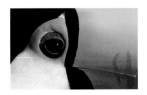

Toucan, Brazil <> *Ramphastos toco albogularis*, pp. 76–77
Toucans add a striking presence to any forest where they occur. Their outrageous bills are complemented by outlandish facial patterns, such as the eye rings of blue skin in this toco toucan.

Jaguar, Brazil <> *Panthera onca*, pp. 78–79
Heavily built and powerful beyond its size, the largest cat in the Americas weighs less than an average human but is legendary for feats of strength. Indians in Surinam once told me how a jaguar flipped a full-grown leatherback turtle weighing 500 pounds ten feet through the air.

Jaguar Pattern *Panthera onca*, p. 80
Like most cats, jaguars do not like to be seen. The rosette pattern in their fur blends with dappled light in the forest, an effect that breaks up the cat's profile and can render it nearly invisible.

Great Argus Pheasant Plumage *Argusianus argus*, p. 81
The wing spots on the plumage of a male argus pheasant are a delicate compromise between the need to be camouflaged and the desire to be dazzling.

Nightjar, Belize *Nyctidromus albicollis*, pp. 82–83
Nightjars are swallows of darkness. They appear at dusk to hunt insects, flitting along the forest edge with a delicate, dipping flight. By day they stay still, pressed against the ground, relying on complete camouflage like this nightjar, a pauraque, nesting on leaf litter in the Cockscomb Basin.

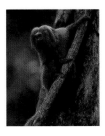

Golden Lion Tamarin, Brazil *Leontopithecus rosalia*, p. 85
Miniscule and twitchy, these primates of coastal Brazil are difficult to follow in the tangled forests where their numbers have dwindled as a result of hunting and habitat fragmentation. They have recently been reintroduced to patches of forest near Rio de Janeiro, where I followed them through the undergrowth by listening for their birdlike chatter.

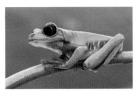

Red-Eyed Tree Frog, Panama *Agalychnis callidryas*, pp. 86–87
His bulging eyes allow this tree frog to see and to signal to others—and they help him swallow. After he zaps an insect with his tongue and snaps it into his mouth he blinks, and his eyes press down into the roof of his mouth, pushing his meal along.

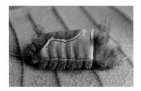

Caterpillar, Belize *Acharia* sp., p. 88
I was drawn to the attractive patterns on this small caterpillar but knew that its colors were a warning. If touched, its stinging hairs would leave me with a painful rash for days to come.

Shield Bug, Borneo p. 89
During their wingless nymph stage, Borneo's shield bugs suck plant sap from leaves. A nasty taste in combination with a warning color pattern serves as a deterrent to would-be predators. Some shield bugs metabolize toxic cyanides as a defense and use a noxious smell to advertise their inedibility.

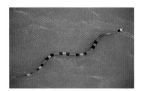

Snake Crossing River, Peru *Erythrolamprus aesculapii*, pp. 90–91
Coral snakes use color as a warning. Many have deadly venoms, but there are also coral-snake mimics, such as this one, whose patterns are similar but whose poisons are milder. Coral snake stripings vary across tropical South America, and the coral-snake mimics adopt local stripe variations to keep up the appearance of their deadly cousins. The phenomenon of a harmless species that mimics a dangerous one is known as Batesian mimicry, named for the pioneering naturalist Henry Walter Bates who explored and collected in the Amazon in the mid-19th century.

Ocellated Turkey, Belize *Agriocharis ocellata*, pp. 92–93
Shimmering like a Chinese mandarin in shiny silks, this tropical cousin of the North American turkey inhabits Central American forests, where it is rapidly disappearing because of bush meat hunting.

Lichen Katydid, Borneo *Olcinia* sp., p. 95
So precise is this katytdid's mimicry that it was hard to spot even as I stood next to it. When I studied it up close I could see that even the surface of its wings matched the textured look of tree-trunk lichen.

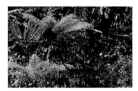

Bonobo, Congo *Pan paniscus*, pp. 96–97
Their black coloration makes it hard to track bonobos in the shadows of the forest canopy.

Ocelot, Peru *Felis pardalis*, p. 98
Ocelots are notoriously shy. You seldom see them, even when tracks reveal their presence. I spent several weeks studying their movements from fresh tracks in the forest to fine-tune the placement of a camera system that uses an infrared beam adapted from a burglar alarm. I finally lured one curious ocelot to my remote-camera set-up, where it triggered its own portrait one rainy night.

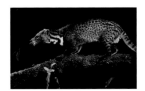

Malay Civet, Borneo *Viverra tangalunga*, p. 99

Like most mammals in Borneo's forests, civets are rarely seen, so I set camera traps around my base camp for them and for an array of other animals, from clouded leopards to treeshrews. Each species required a different approach, and the results were always a surprise. Many rolls of film showed only black frames, or pictures of incomplete animals, cut off at odd angles. This large male paused long enough to allow the camera to record several exposures, giving me rare glimpses into a nocturnal world.

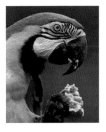

Blue-and-Yellow Macaw, Peru <> *Ara ararauna*, p. 100

A macaw expert once warned me that the bills of large macaws are strong enough to snap a broomstick. Even the hardest seeds pose no problem for these seed predators. Their upper and lower mandibles are designed like a nutcracker and apply maximum force. This blue-and-yellow macaw is dismantling a palm fruit, discarding the flesh to get to the real prize—the nutritious seed at the center.

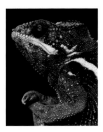

Panther Chameleon, Madagascar *Chameleo pardalis*, p. 101

A chameleon changes color using layers of pigment cells just underneath its transparent outer skin. The pigment cells can expand and contract according to mood, and combine, like paints, to produce different hues. A mellow chameleon tends to be green, but when enraged can turn yellow or red in minutes. Male panther chameleons become especially flamboyant during confrontations with other males.

Leaf-Tailed Gecko, Madagascar *Uroplatus fimbriatus*, pp. 102–103

This nocturnal gecko sports claws on sucker feet, has eyes with four pupils each, and can change colors like a chameleon. It uses the blood-red lining in its mouth as a warning signal. During the day it presses itself to a tree trunk and often dozes dangling upside down.

Red-and-Green Macaws, Peru *Ara chloroptera*, pp. 104–105

In an explosion of color and ear-splitting sound, a flock of macaws takes off from a clay lick while I am watching from a blind perched precariously on a riverbank.

Scarlet Ibis Bathing <> *Eudocimus ruber*, pp. 106–107

There is a sensuous pleasure to watching a bird bathe with swirls of water rolling off its plumage.

Bird of Paradise Plumage *Paradisaea rudolphi*, pp. 108–109

From a scientific specimen, I photographed this detail of the dancing attire of a male blue bird of paradise to show the delicate filigree of tail feathers males use to woo females. In a dazzling display a male swings his feathers, which reflect shades of blue—an irresistible lure to females when presented with the right finesse.

Scarlet Macaw in Flight, Peru *Ara macao*, p. 110
A young scarlet macaw streaks through the understory of an Amazonian rainforest.

Red-and-Green Macaw Family, Peru *Ara chloroptera*, p. 113 (top)
Raising young is a challenge for macaws. Suitable tree holes for nests are hard to find, even in a virgin rainforest.
When macaw couples finally claim a nest site, most can only manage one chick at a time.
Skilled parents can raise two young, which stay with them for months after the young fledge. This family
of four flew past my tower blind, which gave me a unique treetop perspective on their movements.

Red-and-Green Macaws, Peru *Ara chloroptera*, p. 113 (bottom)
I had gone into my blind set up near a riverbank clay lick well before first light, and had to remain motionless for
hours—surrounded by swarms of sweat bees and stinging wasps—before the first macaws tentatively settled on a
liana nearby.

Red-and-Green Macaws on Clay Lick, Peru *Ara chloroptera*, pp. 114–115
After weeks of 12-hour days spent waiting in blinds along the upper Manu River, my reward came when a spec-
tacular flock of red-and-green macaws gathered before me on a clay lick—one of the unique wildlife spectacles
of the Amazon Basin. Macaws gather at these mineral licks to eat clay which, studies suggest, neutralizes the
toxins they ingest with their seed diet.

Flowering Tree, Peru pp. 116–117
There is not a lot of time to focus your lens, let alone reflect on the nature of flowering trees, when you are flying
past them in a single-engine plane, skimming the treetops.

Flowering Tree in Forest, Peru pp. 118–119
In many jungles each tree appears different from the next. As many as 800 species of trees have been
identified in a single acre of tropical forest. The flip side of diversity, however, is rarity. Individuals of the same
kind are often scattered far apart. I spotted this lone flowering tree during an aerial reconnaissance
of the remote Vilcabamba range, reputed last haunt of the Inca.

Pierid Butterflies, Peru Pieridae family, p. 120
Salts and other minerals are at a premium in tropical forests. Most of them are tied up in the living biomass; little
is available in free form. That is why butterflies gather on riverbanks, where retreating water deposits these pre-
cious compounds. Mesmerized by a swirl of pastel-colored pierid butterflies, I approached them slowly in the
noonday sun. It wasn't long before the butterflies began to land on my damp clothes and on my lens's sweaty
focusing barrel in search of salt.

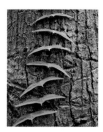

Seedling, Peru p. 121
Nourished only by a decaying leaf, a seedling sprouts on a palm frond ten feet off the ground. I marveled at this humble beginning, an embodiment of the fecundity of life in the jungle.

Climbing Vine, Borneo *Passiflora* sp., p. 124
Reaching for light, a passionflower vine snakes up a tree trunk.

Falling Seed, Borneo *Dipterocarpus* sp., p. 125
A dipterocarp seed whirls down to the forest floor. Its scientific name, appropriately, means "two-winged fruit."

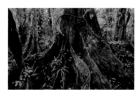

Forest Interior, Belize pp. 126–127
Tree trunks carry nutrients between the forest floor and the canopy. Fallen leaves and other organic debris are broken down by organisms in the soil, then their nutrients are absorbed by tree roots and carried back up to the canopy with remarkable swiftness. In a tropical rainforest, from the moment a leaf falls to earth to the time it is decomposed can take as little as three weeks.

Orangutan, Borneo *Pongo pygmaeus*, p. 128 and cover
Too heavy to leap the way smaller primates do, orangutans travel through the trees with a hand-over-hand motion known as brachiation. They also use their sheer body weight to bend saplings and swing on lianas, pendulum-style, onto a next support. They take the easiest path through the forest, and I have often seen them use the same vines along the same route, day after day.

Flying Frog, Borneo <> *Rhacophorus pardalis*, pp. 130–131
Flying frogs use membranes between their toes to maneuver like paragliders down to the forest floor. In Borneo's jungles an unusual spectrum of animals has mastered the art of gliding flight, from lizards to frogs, lemurs to squirrels—there is even a flying snake. One reason may be the structure of Borneo's forests with their predominance of dipterocarp trees that branch out near the canopy, leaving the midsection of the forest with fewer boughs to serve as pathways for animals to travel. Borneo's forests also have fewer lianas, and according to one theory, this has become an incentive for animals to glide and fly to economize movement between trees.

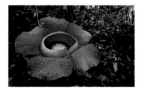

Rafflesia Flower, Borneo *Rafflesia keithii*, pp. 132–133
The largest flower in the world is the only visible sign of a mysterious organism. The plant consists of mere tissue strands within the *Tetrastygma* vine, a type of grapevine that rafflesia parasitizes, and the flower itself which has a diameter of up to three feet. The flower smells of rotting meat, attracting the carrion flies that pollinate the bloom before it collapses in a decomposing mass in a matter of one or two days. I spent a long day with this rafflesia flower, which a biologist friend had spotted just as it was beginning to open. Strobes placed inside the flower illuminate a pollinating fly as it descends into the flower's odorous interior.

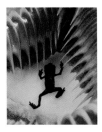

Rafflesia, Inside View, Borneo *Rafflesia keithii*, p. 134
At the end of its bloom, when the rafflesia was starting to deteriorate, the scientist with whom I worked wanted to collect it as a specimen. It was one of the largest flowers ever found of this species, measuring nearly three feet across. Before he cut the flower, I created a hole in which I positioned a camera to show a fly's perspective of the flower and the forest beyond.

Toad inside Pitcher Plant, Borneo *Pelophryne misera* and *Nepenthes villosa*, p. 135
On the slopes of Mount Kinabalu I found a tiny toad inside a pitcher plant. When the lids of old pitcher plants curl back, the pitchers fill with rainwater and become nurseries for frogs, snails, and other creatures.

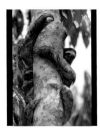

Three-Toed Sloth with Young, Panama *Bradypus variegatus*, p. 137
It takes patience to wait for interesting moments in a sloth's life. Their low-energy diet of leaves dictates a low-activity lifestyle. I had been watching this mother with her young for a while when a shift in their position revealed the presence of another unusual creature on the same tree trunk just below the sloth's foot. I had been looking for one of these strange lantern bugs in the forest for a week, but it took a slow-moving sloth to find one.

Epiphytes, Borneo pp. 138–139
Epiphytes, also known as air plants, require only moisture and a good place to cling; they derive their nutrients from the air and detritus. In the cloud forests on the upper slopes of Mount Kinabalu, as much as 90 percent of the ground cover in certain areas consists of epiphytic orchids.

Cock-of-the-Rock, Peru *Rupicola peruviana*, pp. 140–141
Red-feathered and hot-headed, males of the Andean cock-of-the-rock gather in display areas called leks, where they work themselves into a frenzy showing off to drab-colored females who select the males who will fertilize their eggs. The females alone raise the chicks to fledging, leaving the males free to be dandies. What fuels this extravagance? Some say it is the abundant fruit available in cloud forests, which are too chilly for most monkeys—the birds' chief competitors for this energy source.

Jungle Impression, Costa Rica pp. 142–143
To evoke the disorienting feeling of being surrounded by jungle on all sides without a clear way through, I used a zoom lens to blur the forest for an image with a focal point hidden behind a tree in the center of the composition.

Urania Moth, Peru *Urania leilus*, pp. 144–145
Unlike most moths, which are nocturnal and cryptic, *Urania* moths are colorful day-fliers, like this one spreading its wings to soak up solar energy on a river beach.

Macaws over River, Peru *Ara chloroptera, Ara macao, Ara ararauna,* pp. 146–147
Perched on a scaffold a hundred feet above a clay lick where macaws gather, I had an eagle's-eye view of their comings and goings as they flew over the muddy river below. From that perspective I could see how each species of macaw flashes a distinctive combination of colors and patterns visible only from above.

Flowering Trees, Congo p. 149
After crossing from Uganda over the snow-capped Mountains of the Moon in a single-engine plane, my pilot and I coasted down to the Congo Basin, the second largest expanse of tropical forest in the world. For hours we flew over continuous forest with scarcely a road or a town to break the canopy. Periodically, mass flowerings of trees brightened the sea of green with bursts of color.

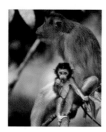

Macaque Infant with Mother, Borneo *Macaca nemestrina,* p. 150
Macaques are versatile primates. They seem willing to try anything and everything at least once. I spotted this mother and infant in a group of pig-tailed macaques coming down to a beach in Sarawak, where they foraged in the intertidal zone for crabs and other crustaceans.

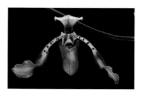

Slipper Orchid, Borneo *Paphiopedilum lowii,* p. 153 (top)
Low's slipper orchid often grows in the forks of dipterocarp trees, high above the ground, but that habit has not protected them from zealous collectors, who have driven this delicate plant nearly to extinction.

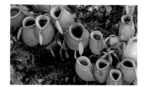

Pitcher Plants, Borneo *Nepenthes ampullaria,* p. 153 (bottom)
These pitcher plants cluster in swampy forests around the lower slopes of Mount Kinabalu. Nectar under the pitcher's rim lures insects, who venture over the edge and slip down inside, where they are digested and absorbed by the plant. Nutrients supplied by the insects enable pitcher plants to grow in poor soils where essential minerals are scarce.

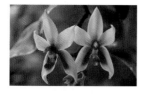

Orchids, Borneo *Phalaenopsis violacea,* pp. 154–155
Like many showy orchids, this pale beauty has become scarce in the wild because of overcollecting. Its partner in nature is a moth, which pollinates the blooms.

Crested Lizard, Borneo *Gonocephalus grandis,* pp. 156–157
A Bornean crested lizard sunbathes on a fallen log at the edge of the forest.

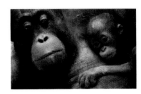

Orangutan Mother and Young, Borneo *Pongo pygmaeus*, pp. 158–159
Orangutans are the least social of all great apes. Their infants grow up clinging to solitary mothers who often forage and travel by themselves, unlike gorillas, chimps, and bonobos, who live in extended family groups. Mass fruitings of figs and other trees, however, create rare opportunities for orangs to socialize.

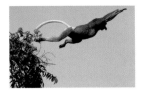

Proboscis Monkey, Borneo *Nasalis larvatus*, pp. 160–161
Proboscis monkeys live in the narrow band of coastal mangrove forests that encircles Borneo. Crossing the tidal creeks that vein their habitat is a routine matter for these monkeys, but for a pot-bellied male reluctant to get wet, it can take an extreme effort. Stretched out and with feet pedaling in mid-air, this one barely made it to the other side.

Lowland Forest, Borneo pp. 162–163
Where a river slices through rainforest, the jungle's architecture is more easily appreciated. This view shows the distinct layering of life zones: ground cover, understory, and tree canopy.

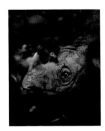

Sumatran Rhinoceros, Borneo <> *Dicerorhinus sumatrensis*, p. 165
Persecuted nearly to extinction for its horn, used in Chinese medicine, the woolly rhinoceros of Borneo has become a shy and nocturnal animal which hides in dense jungle. This individual was brought to a captive breeding facility in a desperate effort to save the species.

Mount Kinabalu, Borneo pp. 166–167
Viewed at dawn from the summit of a nearby mountain, Mount Kinabalu looms like a fortress in the air, girdled by layers of tropical life from lowland rainforest to alpine rock gardens near the summit.

Leaf Ribs, Borneo p. 168
The rigid veins in a leaf serve as pipelines for water taken up by a plant's roots. Carbon dioxide absorbed by leaves combines with the water, and the mix is transformed by the potent chemistry of chlorophyll and sunlight to produce the starch and sugar plants need for their tissue growth. As a by-product of this vital process of photosynthesis, plants release oxygen to the earth's atmosphere.

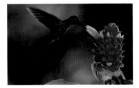

Hummingbird and Ginger Flower, Costa Rica *Heliodoxa jacula* and *Costus* sp., p. 169
As a green-crowned brilliant sips nectar from a torch ginger blossom, it picks up a dusting of pollen which it will carry to the next flower it visits. Tiny flower mites live inside some blossoms and are also dependent on hummingbirds for transport. They have a few seconds to race up a hummingbird's bill to its nostrils, where they wedge themselves for the dangerous flight to another flower.

Tree Canopy, Maui *Acacia koa*, pp. 172–173
The jigsaw-puzzle pattern caused by gaps between tree crowns is known as "canopy shyness," a phenomenon that is not yet fully explained. Some scientists say it is the result of wind friction that wears away outer branches rubbing against each other. Others have called it a tree version of animal territoriality. I have seen this curious phenomenon in a number of places from Malaysia to Hawaii. For this image I dangled from a helicopter over a windy slope of Maui's Pu'u Kukui Reserve to photograph crowns of native koa trees keeping distance from each other.

Passionflower and Guardian Ants, Surinam *Passiflora* sp., pp. 174–175
Passionflowers attract hummingbirds, bees, and other insects, but only hummingbirds can reach deep inside the flowers for nectar and, in the process, pollinate the blossoms. Bees cannot fit inside, so they stage attacks on the passionflower's nectaries by chewing into them from the outside of the flower. There they are fended off by ants, which perform defensive services for the passionflowers. The ants' reward comes from special nectar glands at the base of the flowers—their incentive to keep all other insects away.

Tree Roots, Guatemala pp. 176–177
I went to the ancient Maya temple complex of Tikal to see how a forest can reclaim a city. Tikal was one of the biggest cities in the Americas around A.D. 900, but collapsed within a generation. A millennium after the last Maya walked the city's pavement, trees have covered the former plazas and streets, spreading roots in all directions.

Giant Lobelia, Maui *Lobelia gaudichaudii*, p. 179
The summits of the larger Hawaiian islands have an entirely different climate from the famous beaches below. The higher elevations stimulate cloud formation and rain, which sustains forests made up of intricate communities of native species found nowhere else on earth, such as this giant lobelia in Maui's Pu'u Kukui reserve. A rare break in the weather allowed for a view all the way to Molokai, where clouds drape the flanks of a volcano covered in similar vegetation.

Mossy Forest, Molokai pp. 180–181
Like other boggy cloud forests on the upper slopes of Hawaiian volcanoes, the Kamakou forest near the summit of Molokai is difficult to penetrate because of its spongy ground and dense tangle of stunted trees. During a botanical expedition into similar terrain on the island of Kauai, my companions and I were unable to cover more than a mile a day on foot.

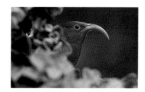

I'iwi, Hawaii *Vestiaria coccinea*, p. 182
The decurved bill of the native honeycreeper known as the *'i'iwi* matches the sickle shape of the tubular blossoms it feeds on. Bird bills and flower forms have coevolved over time.

Heliconia Blossom, Brazil *Heliconia* sp., p. 183
Brilliant color lures hummingbirds and other pollinators to this heliconia blossom, one of many species of this exotic family that grow in the understory of Central and South American jungles.

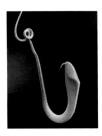

Pitcher Plant Growth, Borneo *Nepenthes stenophylla*, pp. 184–185
The pitcher part of a pitcher plant forms as an extension of a leaf tip. The pitcher begins as an elongated midrib of a leaf, then expands to a bulbous vase shape. Finally, when its lid pops open, the mature pitcher is ready to tempt insect prey to tumble inside.

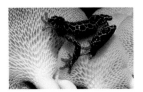

Tree Frog on Mushroom, Peru *Hyla leucophyllata*, pp. 186–187
Found throughout the Amazon Basin, this reticulated tree frog shows the same honeycomb pattern as the underside of the mushroom to which it clings.

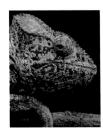

Chameleon, Madagascar *Chameleo oustaleti*, p. 188
The temperament of chameleons suits me. I am as content watching them as they are watching their surroundings for long periods without moving anything but their eyes, which swivel independently. This feature has led to a popular Malagasy proverb that states, "Like the chameleon, a prudent person keeps one eye on the future and the other eye on the past."

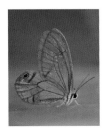

Glasswing Butterfly, Peru *Cithaerias aurorina*, p. 191
If not for the pink flush on their hind wings, glasswing butterflies would be nearly invisible in the dark understory of Amazon forests, where some local people believe these butterflies are the souls of children who have passed away.

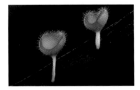

Cup Fungi, Borneo *Cookeina tricholoma*, p. 192
Most fungi are invisible for much of their lives, existing only as tiny threads that penetrate plant tissues, which they break down for their own growth. What we see are their fruiting bodies, which contain reproductive spores.

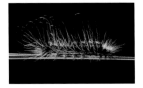

Hairy Caterpillar, Borneo Arctiidae family, p. 193
The long hairs on this tiger moth caterpillar deter parasitic wasps and flies from landing on the caterpillar's body, which the wasps seek to exploit as hosts for their larvae.

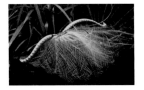

Lyrebird Displaying, Australia <> *Menura novaehollandiae*, pp. 194–195
The Australian jungle has given rise to strange birds. First named *Menura superba*, "the superb bird with the crescent moon tail," the lyrebird in essence is a terrestrial cousin of New Guinea's birds of paradise. Decimated by foxes and other non-native carnivores, only a few lyrebirds still survive in forests along the east coast of the continent. During courtship, male lyrebirds display on bare patches of ground they have meticulously cleared of leaf litter, creating an open stage where they show off their lacy fan of quivering tail feathers to females attracted by their melodious calls.

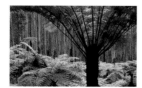

Tree Ferns, Australia *Dicksonia antarctica*, pp. 196–197
In jungles of a distant past, colossal tree ferns dominated forests. The shapes of these now-vanished giants are echoed in modern tree ferns that grow in the understory of giant eucalyptus forests.

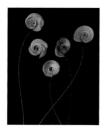

Bird of Paradise Feathers *Cicinnurus regius*, p. 198
Working in a museum collection, I created a bouquet of feathers with the tail pennants from three specimens of the king bird of paradise to accentuate their flowery forms.

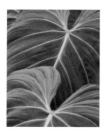

Leaf Patterns, Brazil p. 199
In a botanical garden in Rio de Janeiro, the curves in the tail feathers of the king bird of paradise are echoed in the patterning on a broad-leaf plant native to the Atlantic forest of Brazil.

Woodnymph, Peru *Thalurania furcata*, pp. 200–201
A hummingbird from the eastern Andes, caught in a mist net for an ecological survey, shines with an iridescent sheen caused by the structure of its plumage. Tiny barbs on the feathers of this fork-tailed woodnymph overlap slightly, causing the light bouncing off each layer to split into its spectral components.

Lantern Bug, Borneo Fulgoridae family, p. 203
Lantern bugs are misnamed. They do not actually shine as people once thought. But what its amazing bulb-like process does is still a mystery. These bugs look astonishing at every phase in their life cycle; as nymphs, they resemble bits of walking lichen.

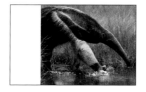

Giant Anteater, Brazil *Myrmecophaga tridactyla*, pp. 204–205
South America's giant anteater has a unique appearance. Lacking teeth, it is totally dependent on its vermicelli-like tongue for its daily intake of more than 10,000 ants and termites. Its formidable claws are designed to tear into termite mounds, but can be raised in an ultimate defense against big cats like jaguars and cougars who prey upon them in the savannas of central Brazil. Near-sighted and shy, this full-grown male never noticed me crouched nearby as he sloshed through flooded grassland in Emas National Park.

Tarsier, Borneo *Tarsius bancanus*, pp. 206–207
Despite its alien looks, there is a kinship between tarsiers and humans. Recent paleontological finds indicate that all primates—monkeys, apes, and humans—may have evolved from a primitive ancestor who lived in Asia 60 million years ago. Today's tarsier, in this new theory, appears to be a living link with that ancient primate which once lived in the forests of what is now Myanmar, formerly Burma.

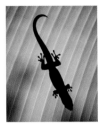

Gecko Shadow, Madagascar *Phelsuma madagascariensis*, p. 208
Seen from below as a silhouette, an emerald-green gecko basks on the sunny side of a banana leaf.
Like 95 percent of Madagascar's reptile species, it is found only on that island.

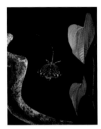

Flying Lizard, Borneo <> *Draco volans*, p. 209
When Borneo's flying lizard casts off from a tree, it utilizes membranes stretched over ribs extending
beyond its body to glide through the forest canopy.

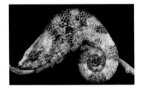

Chameleon Asleep, Madagascar *Chameleo brevicornis*, pp. 210–211
Some chameleons lose most of their color and turn almost white when they fall asleep, such as this *brevicornis*
chameleon resting on a branch at nightfall.

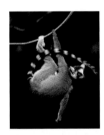

Ring-Tailed Lemur, Madagascar *Lemur catta*, p. 212
Lemurs are descendants of primates that once ranged across Africa, Europe, and North America.
Today some three dozen species of lemurs survive only in Madagascar. In the southern part of the island,
I followed this agile ringtail and others in its noisy troop for several weeks through a riverine forest.

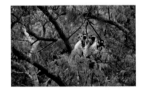

Sifaka Family, Madagascar *Propithecus verreauxi*, p. 215 (top)
Members of a sifaka family huddle together in a tamarind tree in southern Madagascar. The Malagasy
people named this cat-size lemur for its call, emitted as a hissed "shee-faak!" This distinctive sound
allowed me to catch up with these acrobatic primates, whose natural grace propels them through the
trees with amazing speed.

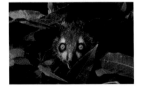

Aye-Aye, Madagascar <> *Daubentonia madagascariensis*, p. 215 (bottom)
The eerie appearance of the nocturnal aye-aye, a strange lemur with leathery bat ears and staring owl
eyes, has earned it a place in Malagasy folklore as a harbinger of death. Some villagers I met were afraid
to even hear its name, but the animal behind the myth, as I got to know it, is a shy creature that smells
of fresh leaves. This individual is emerging at dusk from a daytime nest in an eastern rainforest.

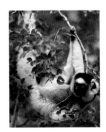

Sifaka, Madagascar *Propithecus verreauxi*, p. 217
Hanging casually from a branch, an adult sifaka forages on young leaves. When I encountered a wounded
sifaka one day, my local guide told me that sifakas practice herbal medicine and that the injured animal
I spotted might heal itself by using one of the many medicinal plants known from the forests of southern
Madagascar.

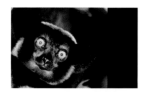

Indri, Madagascar *Indri indri*, pp. 218–219

The largest lemurs alive today, indris look like arboreal teddy bears. Finding a group of them was not difficult, because their spectacular calls carry for several miles in the rainforests of eastern Madagascar, but following them was another matter. During a typical day of tracking I might not get more than a few glimpses of them through dense foliage. But occasionally one would come down to the ground to lick minerals from bare patches of soil, a habit indris share with other lemurs. That gave me the opportunity for close encounters such as with this big male, who stared down at me through a gap in the trees.

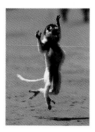

Sifakas, Madagascar *Propithecus verreauxi*, pp. 220–221

The powerful legs that propel sifakas in elegant leaps from tree to tree become unreliable appendages when they have to walk. They move along the ground in awkward yet balletic strides, but cannot stand still without falling over.

Unexplored Forest, Madagascar pp. 222–223

During an aerial reconnaissance of Madagascar, I was intrigued to see tropical forest filling the deeply eroded canyons of a limestone labyrinth in an isolated mountain range that has yet to be explored.

Bonobo Family, Congo *Pan paniscus*, pp. 224–225

At the edge of a forest clearing, a bonobo family group cast glances at me as I observed them from a short distance away in the company of Japanese researchers who knew them well. Even though they saw me in the same spot for weeks on end, the bonobos were always wary. These rarest of all great apes are found only in a remote part of the Congo Basin.

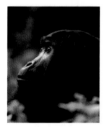

Lowland Gorilla, Congo *Gorilla gorilla*, p. 227

I met this gorilla after a day of tracking his group through dense forest with rangers in Kahuzi-Biéga National Park near the border of the Congo with Rwanda and Burundi. Park rangers had followed the half dozen gorilla groups there for years and knew them all by face and name. But just a mile or two below the park were tent cities housing tens of thousands of war refugees from Rwanda, who later fled into the surrounding forests. When we left this gorilla at the end of the day we knew that his fate was uncertain.

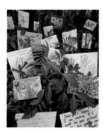

Children's Eternal Rainforest, Costa Rica p. 249

Artwork and letters from children around the world grace the understory of a 55,000-acre cloud forest reserve bought with their donations.

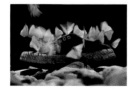

Butterflies on Sneaker, Peru Pieridae family, p. 252

When you spend a lot of time in jungles you inevitably become part of the food chain. Usually it is not the big animals I worry about but the little ones—the insects and smaller creatures who treat humans like any other food source. In an innocent extension of this idea, butterflies have settled on a sweaty sneaker in camp to extract precious salts.

<> symbol indicates animal photographed in captivity

CONSERVATION

For the jungles of the world this is a time of great crisis, but I believe it is also one of great opportunity. Within one generation, people have changed from thinking of forests in places like Borneo and Madagascar as distant spots on the map to realizing that they are vital parts of a global environment we need to protect. Networks of people and organizations are working to guarantee that there will be a future for tropical forests and all life that depends on them. The organizations listed below represent a range of approaches. Some specialize in supporting scientific research; others focus on changing government policy. While some operate at the grassroots level, others coordinate international campaigns. There is a niche and a need for all of them. The perspectives of these organizations may differ, but they share the same ultimate goals, and they all deserve your support.

World Wildlife Fund USA
1250 24ᵗʰ Street, N.W.
Washington, D. C. 20037 USA
www.worldwildlife.org

WWF-Netherlands
Boulevard 12, 3707 BM Zeist
THE NETHERLANDS
www.wnf.nl

WWF-Germany
Rebstöcker Str. 55
60326 Frankfurt/Main GERMANY
www.wwf.de

Rainforest Action Network
221 Pine Street, 5ᵗʰ Floor
San Francisco, CA 94104 USA
www.ran.org

The Rainforest Foundation UK
Suite A5, City Cloisters
196 Old Street
London EC1V 9FR UK
www.rainforestfoundationuk.org

Wildlife Conservation Society
2300 Southern Boulevard
Bronx, New York 10460 USA
www.wcs.org

Conservation International
1919 M Street, N.W., #600
Washington, D. C. 20036 USA
www.conservation.org

The Nature Conservancy
4245 North Fairfax Drive, #100
Arlington, Virginia 22203 USA
www.nature.org

RIGHT: *Children's Eternal Rainforest, Costa Rica,*
PAGE 252: *Butterflies on Sneaker, Peru*

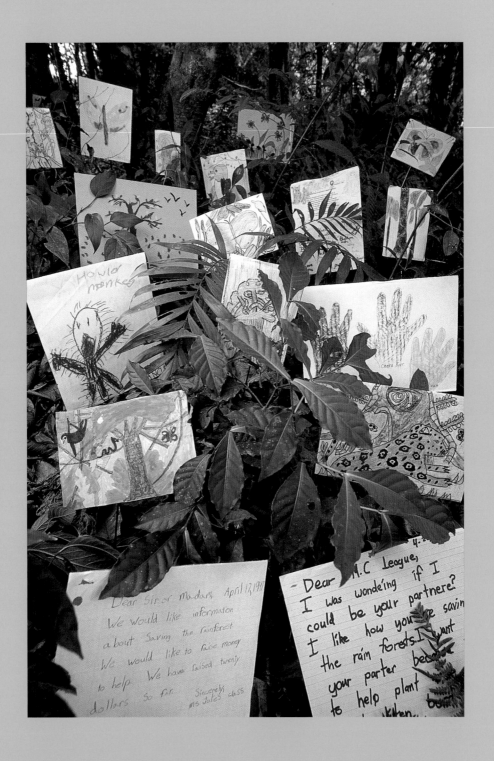

I offer my sincere thanks to all who opened my eyes to jungles around the world, to the publishers and conservation groups who have supported my work, and to the dedicated individuals and organizations who are working to bring wisdom to the decisions about the future of tropical forests.

AFRICA *Madagascar:* Jean DeHeaulme, Bob Dewar, Steve Goodman, Dominique Halleux, the late Bedo Jaosolo, Alison Jolly, Olivier Langrand, Bernhard Meier, Martin Nicoll, Sheila O'Connor, Eckehart Olszowski, Jean-Paul Paddack, André Peyriéras, the late Georges Randrianasolo, Hubert Randrianasolo, Alison Richard; Madagascar Department of Water and Forestry; Tsimbazaza Park. *Congo:* Karl Ammann, Laurent Branckaert, Mike Chambers, Takeshi Furuichi, Nanou Gandibleux, Harry Goodall, Chie Hashimoto, Ellen Ingmanson, Takayoshi Kano, the late Father Piet at Yalisele Mission; John Kahekwa and staff at Kahuzi-Biéga National Park.

AUSTRALIA, ASIA, AND THE PACIFIC *Australia:* the late Jean-Paul Ferrero, Tim Flannery, John Horniblow; Kevin Mason and staff at the Healesville Sanctuary. *Borneo:* Tengku Adlin, Hamid Ahmad, Patrick Andau, Elizabeth Bennett, Ramesh "Zimbo" Boonratana, Louise Emmons, Tony Lamb, the late Clive Marsh, Jamili Nais, Junaidi Payne, Anthea Phillipps, Steve Pinfield, Noel Richard, Simon Sandi, Rob Stuebing; Danum Valley Field Centre; Sabah Foundation; Sabah Ministry of Tourism and Environmental Development; Sabah Parks; Sarawak Forests Department; Sarawak National Parks and Wildlife Office. *Hawaii:* Randy Bartlett, Dave Boynton, Jack Jeffrey, J. Scott Meidell, Hank Oppenheimer; Hawaii Department of Natural Resources; Kapalua Land Company; The Nature Conservancy.

MEXICO AND CENTRAL AMERICA *Belize:* Sharon Matola and staff at the Belize Zoo. *Costa Rica:* Michael and Patricia Fogden, Dan Janzen and Winnie Hallwachs, Frank Joyce and Katy van Dusen, Alan Masters, Glenn Morris, Piotr Naskrecki; Terry Pratt and staff at Horizontes; Rodrigo Gámez, Vanessa Matamoros, and the researchers and staff at INBio; the researchers and staff at Las Cruces Biological Station, Wilson Botanical Garden, La Selva Biological Station, and the Organization for Tropical Studies. *Guatemala:* Vinicio Ruiz; Otto Román and staff at Tikal National Park. *Mexico:* Pablo Cervantes and Elisa García; Jésus and Carolina Estudillo, Patricia and Patricio Robles Gil, Agrupación Sierra Madre; Hebe Alvárez Rincón, Amanda Gomez, Jacqueline and Luis Sigler, and staff at Zoológico Miguel Alvárez del Toro. *Panama:* Claudio Carrasco, Lissy Coley and Tom Kursar, Katy Milton, Dietrich von Staden, Christian Ziegler; Daniel Millan and researchers and staff at the Smithsonian Tropical Research Institute.

A C K N O W L E D G M E N T S

SOUTH AMERICA *Brazil:* Paulo Boute, Maria do Carmo, Peter Crawshaw, Adalberto Eberhard, Renata Egito, Nadir Garcia, the late Claus Meyer, the Rondon family, Leandro Silveira, Ary Soares, Casey Westbrook; Denise Marçal Rambaldi and the Associação Mico-Leão-Dourado; Fernando Dutra, Raquel Werneck, and staff at Fundação Zoobotânica de Carajás; Gustavo Fonseca, Luiz Paulo Pinto, and staff at Conservation International Brasil; Estancia Caiman; Celeste Marizes, Marcia Maria de Paula, and staff at Fundação Emas; Paulo Martins and Helisul; officials and staff at IBAMA; Marta Leitman and staff at Jardim Botânico do Rio de Janeiro; Zalmio Cubas and staff at Parque das Aves; Julio Gonchorosky and staff at Parque Nacional do Iguaçu; Reserva Biologica Poço das Antas; Garo Batmanian, Mauro Giuntini, and staff at World Wildlife Fund Brasil. *Peru:* Daniel Blanco, Billy Evans, Robin Foster, the late Al Gentry, Father Mariano Gagnon, Bruce Holst, Lucia Luna, Walter and Clotilde Mancilla, Charles Munn and Mariana Valqui Munn, the late Ted Parker, Carlos Rivera, Lily Rodriguez, Mónica Romo, Tom Schulenberg, Enrique Tantte Marzano, John Terborgh; Rodrigo Custodio and staff at Inkanatura; Alvaro del Campo, Kurt Holle, Eduardo Nycander and staff at the Tambopata Research Center. *Surinam:* Frans Buissink, Henk and Judy Reichart, the late Joop Schultz; Stinasu.

EUROPE *Germany:* Juliane Steinbrecher, Thomas Grell, Pedro Lisboa, Kathrin Murr, Horst Neuzner, Veronica Weller, and the staff at Benedikt Taschen Verlag and Taschen-America. *Netherlands:* Elsje Drewes, Marleen Drewes; Allard Stapel, Siegfried Woldhek, Hans Voortman, and staff at WWF Netherlands; the doctors and staff at the Rotterdam Havenziekenhuis.

NORTH AMERICA *United States:* John Cadle, Terry Erwin, Harry W. Greene, Charles Handley, Elizabeth Kalko, Tom Lovejoy, Russ Mittermeier, Mark Moffett, Nick Nichols, David Quammen, Kent Redford, the late Barbara and Galen Rowell, George Schaller, George Steinmetz, Edward O. Wilson; Academy of Natural Sciences of Philadelphia; Atlanta Botanical Garden; California Academy of Sciences; Smithsonian Institution; Eric Dinerstein, Kathryn Fuller, Dave Olson, and staff at World Wildlife Fund USA. *National Geographic Society:* John Agnone, Bill Allen, Bob Booth, Rich Clarkson, Bill Douthitt, Neva Folk, Bill Garrett, Bob Gilka, Will Gray, Alex Hawes, the late Ann Judge, Tom Kennedy, Kent Kobersteen, Al Royce, Mary Smith, Susan Smith; Larry Maurer and staff at Photo Engineering. *Technical Support:* Bill Atkinson; Joe Levine and staff at Calypso; Tom Curley and staff at Fuji; Uwe Mummenhoff and staff at LowePro; Jerry Grossman and staff at Nikon; Rich Seiling and staff at West Coast Imaging.

SPECIAL THANKS TO: Sam Petersen, Isabel Stirling; Sabrina Dalbesio, Anya Pastor, Mary Salazar, and the staff at the Frans Lanting Studio. I owe a special word of thanks to Jane Vessels for her fine professional judgment; to Kristen Wurz for excellent production assistance; to Jenny Barry, our superb collaborator in creating this book; and to Benedikt Taschen and Angelika Taschen for their trust and support.

To Chris, my partner in life and work, my gratitude and love.

Produced by Frans Lanting and Christine Eckstrom for Terra Editions in association with Benedikt Taschen Verlag

Copyright © 2000, 2005 Terra Editions

www.lanting.com

Published by TASCHEN GmbH

Hohenzollernring 53, D-50672, Köln, Germany

www.taschen.com

To stay informed about upcoming TASCHEN titles, please request our magazine at www.taschen.com or write to TASCHEN America, 6671 Sunset Boulevard, Suite 1508, USA-Los Angeles, CA 90028, Fax: +1-323-463.4442. We will be happy to send you a free copy of our magazine which is filled with information about all of our books.

Photographs and text copyright © 2000 Frans Lanting

Editor: Christine Eckstrom, Santa Cruz, California

Design: Jennifer Barry Design, Sausalito, California

Cover: Orangutan, Borneo

All rights reserved.

No part of this book may be reproduced in any form or by any electronic or mechanical means, including information storage and retrieval systems, without prior written permission from the publisher or the producer, except by a reviewer who may quote brief passages in a review.

Library of Congress Catalog Card Number: 00-102915

ISBN 3-8228-4245-1

Printed in Italy

Fine prints, books, and information about Frans Lanting's work are available from the Frans Lanting Studio in Santa Cruz, California.

Please write to info@lanting.com or visit www.lanting.com.

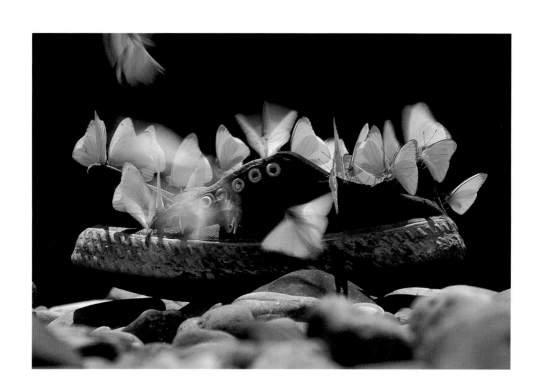

ABOUT THE BOOK

JUNGLES is a personal exploration of nature in the tropics by master photographer, storyteller, and naturalist Frans Lanting. In a unique collection of images made over a period of 20 years in jungles from the lowlands of the Congo to the cloud forests of the Andes, Frans Lanting interprets the aesthetic splendor and the remarkable natural history of the tropical rainforest–a realm of bewildering complexity where nothing is the way it first appears. "While the essence of photography is to show, jungles hide, or at best, suggest," Lanting writes. "So I opted to show impressions of jungles to evoke a sense of their kaleidoscopic nature–the glimpses of faces that melt into shadows, the bursts of color and shimmering light."

The book features four portfolios of images that blend the results of travels years and continents apart. Within the portfolios are stories of field expeditions into tropical wilderness areas. "Water and Light" shows the interplay of these elements with plant and animal life, and ends with a story about life after dark in the jungles of Central America. "Color and Camouflage" explores the need to hide and the desire to be seen, and details a journey to a remote part of the Amazon Basin to document macaws. "Anarchy and Order" features impressions of growth and movement, and leads to a trek up a mountain in Borneo whose forested flanks show a unique layering of life zones. "Form and Evolution" is an ode to the wonders of natural selection, and culminates in encounters with primates in the forests of Madagascar and Africa.

In photographs that range from spectacular gatherings of rainbow-colored macaws to the misty exhalations of a forest at dawn, Frans Lanting evokes the luscious sensuality and intricate natural order of the forests that shelter the ultimate expression of life on earth. "This book is a personal vision of jungles," Lanting says. "It is about the feeling of the forest rather than the science of it."

BIOGRAPHIES

FRANS LANTING has been hailed as one of the great nature photographers of our time. His influential work has appeared in books, magazines, and exhibitions around the world. For more than two decades he has documented wildlife and our relationship with nature in environments from the Amazon to Antarctica. He portrays wild creatures as ambassadors for the preservation of complete ecosystems, and his many publications have increased worldwide awareness of endangered ecological treasures in far corners of the earth.

Lanting has received numerous prestigious awards. In 2001 H.R.H. Prince Bernhard inducted him as a Knight in the Royal Order of the Golden Ark, the Netherlands' highest conservation honor. He has received top honors from World Press Photo, the title of BBC Wildlife Photographer of the Year, as well as the Sierra Club's Ansel Adams Award.

His books include *Penguin* (1999), *Living Planet* (1999), *Eye to Eye: Intimate Encounters With the Animal World* (1997), *Bonobo, The Forgotten Ape* (1997), *Animal Athletes* (1996), *Okavango: Africa's Last Eden* (1993), *Peace on Earth* (1993), *Forgotten Edens* (1993), and *Madagascar, A World Out of Time* (1990). Exhibits of his photographs have been shown at major museums in Paris, Milan, Tokyo, New York, Madrid, and Amsterdam.

CHRISTINE ECKSTROM is a writer, editor, and videographer specializing in natural history. She is the author of *Forgotten Edens* and a contributing author of more than 15 books published by the National Geographic Society. The editor of *Eye to Eye*, *Okavango*, and *Penguin*, she collaborates with Frans Lanting on fieldwork, books, and other publishing projects from their home base in Santa Cruz, California.